MOVEMENTS IN MODERN ART

M◐VEMENTS IN

DONALD CARROLL and

HORIZON PRESS

M⊖DERN ART

EDWARD LUCIE-SMITH

New York

For Irene and Geoffrey

Contents

Illustrations

MOVEMENTS IN MODERN ART

I
Cubism / Futurism

DONALD CARROLL. If you had to choose one time and place, or one painter and painting, which you could point to and say, "Modern art begins here", what would you point to?

EDWARD LUCIE-SMITH. I can narrow it down a bit further than that, I think. I'd choose a little bit of one painting, and the painting is Cézanne's *The Bathers*, which is in the National Gallery in London. And the little bit is the sole of the foot of one of the figures who is reclining, pointing into the space of the painting, and her foot is pressed, so to speak, against the picture surface. And it's pressed so hard against that picture surface that it distorts, it becomes just a flat area of paint with a blue line around it. This seems to me really the beginning of abstraction in modern art, and a very important moment.

DC. In that case, would you go beyond that to say that Cézanne was the first modern artist?

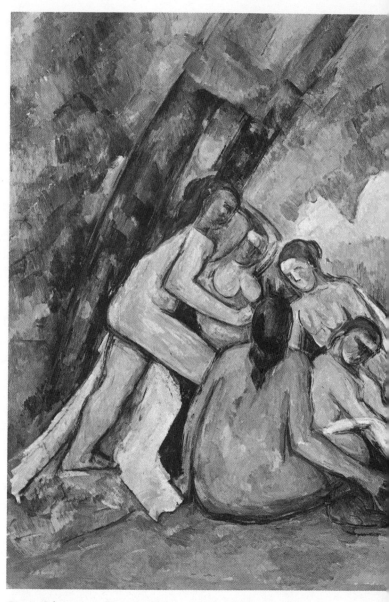

Paul Cézanne, *The Bathers,* 1900-1905, oil on canvas, 130 x 195 cm. National Gallery, London.

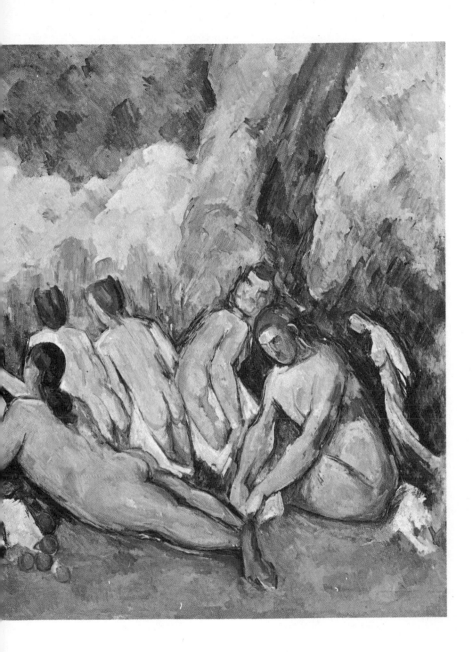

ELS. I'm a little reluctant about that. Cézanne is the joker in the pack. He is the artist who is uncovenanted for. He doesn't really fit in, to my mind, to the story of the development of modern art, and the attempts which were made by critics such as Roger Fry in the twenties, to make Cézanne the very source of modernism, seem to me to be misguided.

DC. Well, if he's a deviant, he's certainly a very influential deviant.

ELS. An enormously influential deviant, chiefly because he treated the picture as an object, as a surface, which had to be unified in some way, and that has had a great influence on painters since his time.

DC. How would you relate him to, say, the Impressionists or the Symbolists? Because this is where we get into the tributaries that lead into the mainstream of modern art.

ELS. Cézanne, as you know, started as an Impressionist, and exhibited in some of the Impressionist exhibitions. The Impressionists were part of a much broader movement, which was that of nineteenth-century Naturalism. It's no accident that the novelist Emile Zola was one of the great supporters of Impressionist art.

DC. He was also a close friend of Cézanne.

ELS. Yes, indeed. And the whole idea was that the natural world was all there was, that the eye was a truthful instrument and you must believe the eye. This was according to the Impressionists. And Cézanne took this

a bit further by trying to give reality not merely the density which the eye found in it, but the density which experience found in it. And that was the sense in which he was an innovator philosophically.

DC. I remember your saying to me once that modern art really starts with Baudelaire, that the whole modernist movement in the arts began with Baudelaire.

ELS. Well, there's a constant shifting back and forth of leadership between literature and music.

DC. Of course the Symbolists began, basically, as a literary movement, did they not?

ELS. They certainly began in France as a literary movement. But there is also an argument for saying that Symbolist painting as such began in England with the Pre-Raphaelites.

DC. What is that argument? I'd like to hear it.

ELS. Well, the argument is that the first really important nineteenth-century Symbolist artist is William Blake, and that one can trace a land line through to Samuel Palmer. And then, rather more tenuously, to Richard Dadd who, as you know, was a madman who was locked up for his madness. And then to the early Pre-Raphaelites in the 1850s, to Dante Gabriel Rossetti, to Millais, to Holman Hunt. And then after the first decade of Pre-Raphaelitism—what's now sometimes called "hard-edge Pre-Raphaelitism"—was over, you have the second wave where Rossetti influences Edward Burne-Jones and William Morris. For me personally, Symbolism begins in

the England of the 1860s. It begins with the later paintings of Rossetti—all those soulful ladies unlocated in space against symbolic backgrounds—and it begins with Burne-Jones's distortions of space, and his distortions of picture format. As you may remember, his pictures tend to be either very tall and thin or very long and narrow. The long and narrow ones are modeled on Florentine Cassone panels.

DC. But how do these various streams coalesce? The Impressionists, the Symbolists, the Pre-Raphaelites and the rest of them are all basically Romantic movements, are they not? They're all throw-backs to the Romanticism of the eighteenth century.

ELS. Well, yes and no. I think Naturalism is related to nineteenth-century discoveries in science. Impressionism, as you know, being based on the division of colors, is actually based on nineteenth-century scientific exploration of the behavior of light.

DC. It's also based to a certain extent on nineteenth-century technology. For example, the Impressionists were the first painters who actually had paint in tubes, so they could get outdoors to do their painting.

ELS. That's not quite true. That began with the Barbizon painters, who are Naturalists of a slightly earlier generation, people like Rousseau, Harpignies—artists of that group. What the Impressionists did was to carry open-air painting to the degree of its being a scientific principle: that you *had* to paint that way in order to paint truthfully. Just as you had to research into real life, according to

Zola, in order to write truthfully. The Symbolists reacted away from this. They found this too confining. They wanted painting to be a separate realm from life, just as they wanted literature to be a separate realm from life. Here you get the beginnings of art for art's sake, and you also get, of course, a moral reaction.

DC. You also get Primitivism, don't you?

ELS. Not to begin with. You get the cult of exoticism first of all. That starts with Flaubert. It starts with writers. It starts particularly with *Salammbô* and with *The Temptation of St. Anthony*. And then you get the cult of decadence, where you have another writer as the leader, J.K. Huysmans, with *A Rebours*, best translated as "Against Nature", and *Là-Bas*, which is his book about satanism. You get the whole idea of reversing the moral order, first of all. And then after you've reversed the moral order you get the idea of reversing the aesthetic order, which comes with Gauguin.

DC. As we're creeping up on Cubism, perhaps you could tell me what was the overall condition of European culture at this time? What made all of these things—on all four burners, as it were—come to the boil at once?

ELS. Well, European culture in the nineteenth century was, after all, very international. One traveled without passports. Ideas were communicated remarkably quickly between countries. And one of the mistakes we've made in our own nationalist age is to insist on classifying the visual arts according to national boundaries. Symbolism resembled the Mannerism of the late sixteenth century,

being a totally international style, as valid in Russia as in Munich.

DC. Many people have said the same of Cubism, that Cubism seems to be similar in many ways to Mannerism.

ELS. I don't believe that Cubism is an international style. I think it was a purely French phenomenon.

DC. So you think it was this boundarylessness that gave Symbolism, and what followed it, its great impetus in the late nineteenth century?

ELS. Well, Symbolism started with the Decadents, so-called, in the mid-eighties of the nineteenth century. It became a more general phenomenon somewhere around 1890. In Paris it centered upon Mallarmé, but it also embraced all sorts of other centers. It embraced the Munich of the Jugendstil. It embraced the St. Petersburg of Alexander Benois. It turned up in America with Arthur Davies and John Singer Sargent's decorations for the Boston Public Library. Of course it flourished in England with late Burne-Jones and Beardsley. It flourished in Barcelona, where Picasso received his first training as an artist. So, in a sense, an artist could travel throughout Europe, certainly throughout central Europe, without ever feeling himself an alien if he subscribed to any form of Symbolist creed. He could go to Milan, where people such as Segantini were well-known. He could go to Switzerland, which produced Hodler. He could go to the other cities I've mentioned, and he would always find some artists who were at least related to his own way of thinking.

DC. Before we leave the nineteenth century, there's another idea of yours that I wanted to ask about, and that's the idea that Puvis de Chavannes—a little-regarded artist, and in my opinion rightly so—is in fact one of the seminal influences in twentieth-century art.

ELS. I think that's perfectly true, and also relatively easy to explain once you've thought of the explanation. Puvis represents an impulse which I think was very strong in Symbolist painting. Remember, Symbolist painting was much more interested in ends than in means. They didn't care about being academic or being anti-academic, so long as the end result conformed to, broadly speaking, some kind of Symbolist credo. And Puvis represents the desire both to be avant-garde and to remain related to respectable academicism.

DC. Do you have any paintings in mind that illustrate this, or exemplify this?

ELS. Well, I think one has two different kinds of Puvis. One is found in those decorations in places like the Sorbonne: large classical ladies, or large medieval ladies, depending on the subject, but certainly very academic, very carefully planned, held together by this grayed color which is Puvis's most striking characteristic. And then you have a series of rather smaller pictures—sometimes in our modern terms quite large pictures, but certainly not the size of a whole building like some of the decorations. And these are very often much more individual. The one which I think sticks most in the memory is *The Poor Fisherman* in the Louvre, which shows this figure

in a boat in a kind of *Pelléas et Mélisande* landscape—you see, I name a Symbolist play by instinct—with a few other figures looking rather depressed on the bank. And this represents a carefully distanced, carefully self-stylized, very self-conscious world. And it was the unity of this world which attracted Puvis's contemporaries. It was possible to see that here was art, and that real life was on the other side of a barrier which the artist had erected against it.

DC. This world then ended—or a new world began, depending on your point of view—with Cubism. For you, Cubism is in fact the end of an era rather than the beginning of an era, isn't it?

ELS. Let's put it this way: I think Cubism is, in some respects, a revival of the Naturalism of the 1860s and 1870s. It represents a desire to get back to what was real. It represents a desire to tackle observed and experienced reality in a head-on way, in a way which would still work. It's a last desperate throw for the standards of academic painting.

DC. The last attempt to make reality work.

ELS. Yes, indeed.

DC. But isn't that partly because it had new competition at that time from photography?

ELS. Yes, I think that's exactly the reason. You see, the Courbet type of Naturalism, which had preceded Impressionism, could no longer make a valid statement because the photographer could do it almost as well, or perhaps

on some occasions as well or better. So the painter had to explore the ways in which his intelligence would make reality more clearly perceptible to the spectator than the camera could.

DC. At the same time, surely, Cubism was revolutionary in that it broke away from the classic norm for the human figure, and got away from the one-point perspective. Now I know that in getting away from the one-point perspective it was, in a sense, trying to be one-up on photography. But it was still a revolutionary development at that time.

ELS. Well, let's look at Picasso and see what happened. Picasso begins his career as a painter under the influence of Toulouse-Lautrec, and also of Steinlen, which is a kind of urban realism, a caricature realism if you like. He then becomes, in his Blue Period, around 1903, a Symbolist. In fact he is one of the late great Symbolist painters.

DC. Isn't this a somewhat heterodox attitude?

ELS. It's always been recognized that Picasso was a Symbolist in the Blue and Rose Periods, but it's never been said in a very loud voice because it's an inconvenient fact. But it is a fact nevertheless. Anthony Blunt and Phoebe Poole wrote a book about early Picasso which contains a great deal of documentation on this subject. A painting like *La Vie*, the big Blue Period Picasso which is now in Cleveland, is exactly comparable to the kind of thing which Munch was doing at roughly the same period.

DC. And Klimt.

ELS. And Klimt also, yes. They are the summation of a philosophy of life. And in Picasso's case the technical means go back to Redon for some of the physical types, but chiefly to Puvis de Chavannes, with his angular figures isolated against the background and with the carefully unified, rather subdued color.

DC. Redon was certainly a great influence on Picasso's Blue Period.

ELS. Yes. Redon had something of the magical about him. Picasso has always been interested in the magical, even in a kind of witch-doctor sense. And that is what attracted him. He saw an exhibition of Redon's when he first came to Paris—I think he saw it in 1901—an exhibition of pastels, and it clearly had a great influence on him. All those hollow-cheeked harlequins are related to the heads which you see in Redon's painting. But I think the main influence is the academicizing influence of Puvis. Also, the harlequins come out of it with a side of Symbolism which turned not toward the Middle Ages, like Burne-Jones did, but toward the eighteenth century, which one sees in Conder for example. Conder is a man who follows a long way after Watteau and Benois, and who was obsessed with the late seventeenth and the eighteenth century. And Previati in Italy is another example.

DC. Redon also contributed one of the first adaptations of a nineteenth-century scientific discovery, the use of the microscope, in the shapes he saw through that microscope.

ELS. Yes, but one doesn't find that in Picasso. Picasso is an old-fashioned artist in that sense. The two major Symbolists who were influenced by what one saw through the microscope, who were influenced by the visual truth of science, if one can put it that way, were Redon, who was not only an assiduous visitor to the Jardin des Plantes in Paris but was also clearly interested in the sort of things one saw in a drop of pond water through a low-powered microscope, and the Norwegian Edvard Munch, whose pictures often came to contain allusions to the shapes of things like spermatozoa, for instance. I think that Picasso is trying to assimilate Puvis and Beardsley and Burne-Jones, and is trying, so to speak, to hold the line against Naturalism. And then he does what many Symbolist artists did before him. He becomes attracted by the Primitives, just as Gauguin had been attracted by the Primitives. Gauguin is another great influence. There was a great retrospective of Gauguin in Paris in 1903, which Picasso was clearly influenced by. In fact, Symbolist taste, with its feeling for the complicated, for the exceedingly difficult, for the hermetic, suddenly reacted on many occasions into a taste for the crude and the primitive. Refined people have always been attracted by the exact opposite.

DC. When one looks at Cubist art—Picasso, say, or Braque, or Gris, or Léger—it seems that a whole new realm has opened, totally different from that which had gone before. And yet you say it's a Romantic back-number.

ELS. No, a Naturalistic back-number, which is some-

thing rather different. I think the problem is that people always underplay the importance of the linking period between Picasso's Rose Period and straightforward Cubism, which was the so-called Negro Period. You know, there's a great deal of argument as to whether he really was influenced by Negro sculpture.

DC. Well, *he* keeps denying it—but his paintings keep affirming it.

ELS. The principle masterpiece of that period, *The Demoiselles d'Avignon*, is a statement in favor of Primitivism, and it's like the kind of statements which were made by the Russian painters, Mikhail Larionov and his wife Gontcharova, who turn to Russian folk art instead of to African sculpture because to them Russian folk art, of course, was much more available. But I think also you must remember that *The Demoiselles* was intended as an insult. Even that untranslatable title indicates this. Because what the title means—and everybody tends to forget this, or they gloss it over—isn't "The Young Ladies of Avignon" at all. It's "The Tarts of the Calle D'Avignon in Barcelona"—that is, the lowest class of whore in a city which was fairly famous for its whores. The title was suggested jokingly by the poet Andre Salmon, who was a friend of Picasso's at that time. In fact the whole idea of *The Demoiselles d'Avignon* is deliberate ugliness.

DC. Which is one of the traits one ascribes to painters of that period, as *scandale* followed *scandale* after each opening in one salon after another. One almost senses a desire to shock, a desire not only to paint a painting but to make a statement saying, "Take that!"

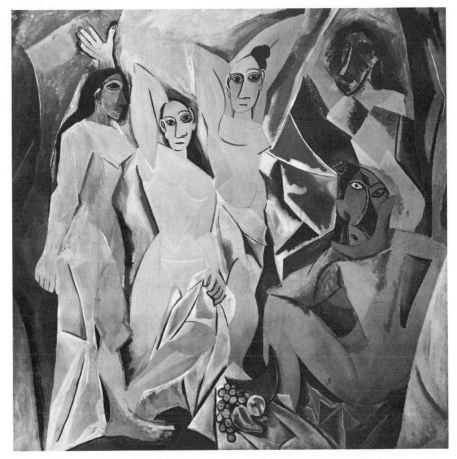

Pablo Picasso, *Les Demoiselles d'Avignon,* 1907, oil on canvas, 8 ft. x 8 ft. 7 in. Collection The Museum of Modern Art, New York. Lillie B. Bliss Bequest.

ELS. I think *The Demoiselles* was certainly a statement which said, "Take that!"—in the sense that the first Fauve pictures of 1905 had also been pictures which said, "Take that!" I think that Braque and Picasso then saw in *The Demoiselles* technical possibilities which hadn't previously occurred to them. The whole technique of splitting up and faceting, which Braque applied to the *Landscape at L'Estaque*, which is really the next stage in the development of Cubism, was because I think artists often do things without wholly realizing what they've done. They look at what they've done afterwards and say, "Yes, well, if I've done so-and-so, then I can develop it in this way, which I hadn't thought of previously." And I'm sure that's what happens.

DC. Do you think that could possibly be the genesis of *papier collé*?

ELS. I think that *papier collé* was much more logical than that. If you take Cubism as being in its first stage a developing obsession with reality—a quarrel with reality almost, a determination to force reality into painting again, to make it speak, as it seemed almost unable to speak—then it would seem logical to put in a piece of undiluted reality, like a piece of newspaper, or a piece of wallpaper, or a piece of chair caning, almost as a kind of pledge that that was what you were after: the real thing, not the fake thing, not the symbolic thing.

DC. This was the validation on the parking ticket.

ELS. Yes, indeed. The stamp. Reality itself was there to speak for you, not translated.

DC. One of the Cubists that has always interested me is Léger, simply because he's different from the others. Why do you think Léger's work is so different?

ELS. I think because Léger never wholly gave up color.

DC. You mean he didn't subordinate it to the demands of formalistic concepts?

ELS. Exactly. And I think that that means in turn that he didn't really understand what Braque and Picasso were after. You see, the thing about Cubism is this. Every time you do something in the arts you may have an idea that there is another stage in front of you which you can then encompass. Having done the first thing, you do the second thing. But having moved from square one to square two, and as you are preparing to move to square three, you discover that there are two or three doors which you can choose from, instead of just the one you had envisaged. And I think this is true of Cubism. I think there were two things which the original Cubists, Braque and Picasso, hadn't envisaged. They didn't at first envisage the decorative possibilities of the shapes they were making. The move from synthetic to analytic Cubism was unplanned, and was in one sense a concession of defeat. And the other thing which I think they hadn't properly explored was the idea of simultaneity which they had imported into painting. If we can take simultaneity first, because I think it's more fundamental, when you talk of shifting viewpoints what you mean is that a so-called analytic Cubist picture, a Cubist picture shall we say between 1909 and 1911, actually encourages you

to move around the objects or the personage represented. And the reason why such simple things have to be shown is that you are presented with very complex viewpoints, very complex series of viewpoints. The object unfolds before you from viewpoint to viewpoint. It's almost as if you walked around it. Which is the reason, incidentally, that Cubist sculpture of the early Lipchitz variety was, I think, so unsatisfactory—because it's doing in the flat things which sculpture can do anyway in three dimensions. And somehow it doesn't work. It's true of Naum Gabo; it's true even of some of Picasso's Cubist sculpture. Simultaneity introduced the notion of time, which is a thing I think the painters had not thought of. Obviously to move around an object takes a little time—however little, a second perhaps—so there is the idea that the painting is not a unitary experience any more. And that is the link between French Cubism and Italian Futurism.

DC. Which is the crucial link, because in your opinion Futurism rather than Cubism is really the first modern movement in art.

ELS. I think in a general sense it undoubtedly has to be so, because Futurism was international, as Cubism wasn't.

DC. Well, it did begin outside Paris, which makes a change for a start.

ELS. Not quite outside Paris.

DC. Of course Marinetti's manifesto was first published in Paris, but . . .

ELS. Yes, the first Futurist Manifesto was published in 1909 in Paris, the reason being that Marinetti believed that by publishing it in a French newspaper he would get much more attention than in provincial Italy. He was using Paris as a soapbox from which to shout to Milan.

ELS. And it worked.

ELS. And it worked. Marinetti, as you know, was not a painter but a poet and a polemicist. And he started off as a Symbolist. He used to write for *La Revue Blanche*, which was the most important of the late Symbolist periodicals, which was edited by Thadée Natanson, who was once upon a time married to Misia Sert, who was the favorite model of Vuillard, and so it goes on. And Marinetti's whole idea was, first of all, a simple revolt against the medieval aspect in particular of Symbolism. His second manifesto—I think it's the second, certainly one of the early ones—is headed with the words, *Tuons le clair de lune*. "Murder the moonlight." You see, the moonlight thing is very much a Symbolist thing, and Marinetti's whole creed was virility, love of war . . .

DC. It was almost a glorification of war.

ELS. It *was* a glorification of war. And nationalism.

DC. And machinery.

ELS. Yes. The most famous phrase in the first Futurist Manifesto is, "The racing automobile is more beautiful than *The Winged Victory of Samothrace*." But here again they meant to shock, to shock that over-refined, pre-War

society. Futurism, in one sense, was only interested in mechanical motion, in simultaneous states.

DC. A celebration of the dynamics of movement, of machinery.

ELS. Yes, but these were incidental to Futurism.

DC. Then why have they become so closely identified with it?

ELS. I think because they were easily rendered by a kind of mechanical technique, which anybody could learn. The Futurists also meant to render moods, which is what they inherited from the Symbolists, and that's much more difficult. As you know, Boccioni did pictures of those who go, those who stay, and so forth. Boccioni, in the attempt to render mood, was actually reaching beyond Cubism to Fauvism. The very bright colors of the Fauves—which in turn derive from Gauguin, who used color to transcribe emotion—were an attempt to give a color to reality, to force upon reality what the painter thought and felt about it. And I think that the Futurists wanted to do something which was very similar. The grayed colors of analytical Cubism—as you know, the great analytical Cubist pictures are almost monochromes—were a rejection of emotion in favor of some kind of logical order. They were, one might almost say, an assertion of the French classical tradition, a desire to make it seem that Cubism was the heir not only of Puvis de Chavannes but before that of Jacques-Louis David and before that of Poussin. On the whole, the use of non-realistic color is very widespread in the decade

before the First World War. The Fauves exploded in 1905 in Paris. And you get an exactly similar use of color among the German Expressionists in Berlin. You get a more restrained use of color—but still in the same sense—in Munich, with the artists of the Blaue Reiter: Kandinsky, Jawlensky and Franz Marc.

DC. Fauvism has always seemed to me more an epithet, which indeed it was originally, than a category, because how two artists as dissimilar as Matisse and Rouault could be members of the same school . . .

ELS. They did have something else in common, which was that they were both pupils of Gustave Moreau, who was one of the founders of Symbolism. Moreau said to his pupils, and it's a fine phrase, "I am the bridge which some of you will cross."

DC. And quite a few did.

ELS. And quite a few did. But they crossed it in different ways, if a bridge can lead to different countries. Matisse concentrated on producing a feeling of well-being. One could say—and it sounds a bit pejorative, but I also think it's true—that he tried to reconcile bourgeois values with experimental art, that his whole idea was to say to the bourgeoisie, "Lie back, relax and enjoy it. You can actu ally get something out of this kind of thing. I will provide you with a feeling of well-being and comfort." Rouault was very different, very much closer to Moreau. He was in fact eventually, after Moreau's death, the custodian of the Musée Gustave Moreau, which has the contents of Moreau's studio and house, which were left to the

state. He is the nearest thing in French painting to a German Expressionist: all those tarts and crucifixions and sad-eyed harlequins and that kind of thing. He brings out the link between Symbolism and Expressionism. Symbolism led all ways, you see. It led to Expressionism as well as leading to Matisse's tendency to shut out feeling in favor of a calm sensuality.

DC. Do you ever sit down and try to work out a family tree of art? I've traced about three branches of Impressionism and about four branches of Symbolism, and when you get to the bottom you find the roots are just as tangled as the branches are.

ELS. Well, everybody tries to do that because it's the only way in which we who come after can make sense of artistic developments. We impose various schemes, various patterns on them. And none of these patterns is absolutely true. The pattern which says that Cubism is the very center, the place where modern art begins, is generally accepted, thanks to the efforts of Roger Fry. But to me personally it seems to be untrue. In fact what seems to me to have happened was that one had Romanticism, Naturalism, Symbolism. And then one had Primitivism, in the sense of the Picasso Negro Period and early pictures by Van Gogh and Gontcharova. And then one had Futurism, which was a leap out of Primitivism into the worship of machinery. An interesting reaction. And although Futurism was a widespread movement which appeared in Italy, it certainly had roots in France with people like Delaunay. One finds traces of it in Léger. Léger is an artist who is very fascinated

by machine shapes. It's one of the things that marks him off from Picasso and Braque. And in England one has that short-lived, but absolutely fascinating, avant-garde movement, Vorticism, led by Wyndham Lewis.

DC. What you have been saying up to this point, then, is that Cubism was a recessive gene in the creation of art and that Futurism was a manifestation of the dominant gene.

ELS. I think that's exactly true. But I think that Cubism has more masterpieces to its credit.

DC. Like the *Three Musicians*, which is probably its last masterpiece.

ELS. Yes, indeed. A masterpiece which is produced by Picasso after both analytic and synthetic Cubism are virtually over. And what makes the two versions of it—as you know, there are two versions which differ in small details—what makes them so intensely satisfactory as pictures is that the artist is working within limits which he has thoroughly explored. You no longer have the straining to present reality in all its aspects. The artist simply uses techniques with which he is very familiar, faceting and so forth, to produce these flat color areas, which are assembled into a totally satisfactory pattern which exists entirely beside reality. Reality has been, so to speak, defeated. And the artist accepts that defeat.

DC. What I still don't see is what formalistic boundaries were crossed, or bulldozed, by Futurism that hadn't been crossed by Cubism.

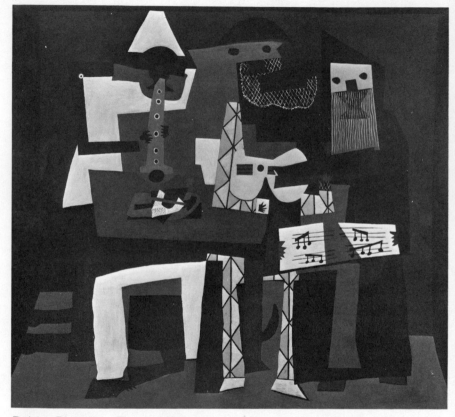

Pablo Picasso, *Three Musicians,* 1921, oil on canvas,
6 ft. 7 in. x 7 ft. 3¾ in. Collection The Museum of Modern
Art, New York. Mrs. Simon Guggenheim Fund.

ELS. I think that Futurism, by its very name, had a commitment to the idea of the future. Of course it was invented by a non-painter, in the person of Marinetti, and it's one of the characteristics of all these movements on either side of that divide which is marked by 1900 that people who didn't paint . . .

DC. So it was not only a manifesto, but a prescription?

ELS. Exactly. You see, Marinetti was a travelling prophet who lectured all over the place. And one could name two other travelling prophets who are in exactly the same position, only both of these two happen to be French. One was a man called Joseph Péladan, who was the great prophet of Symbolism in painting in France and the organizer of the Salons de la Rose et Croix, the first of which was in 1892. He caused a huge stir in the nineties and traveled to Holland and traveled to Belgium, lectured all over the place, wore funny clothes, wore a funny hat, wrote endless novels on the model of Flaubert's *Salammbô*, published tracts about aesthetics, was a friend of Verlaine's, and was mistrusted by Puvis de Chavannes, whom as it happened he worshipped. And then he meets Marinetti, who does the same thing—who gives vast public lectures, who travels to Russia and shouts at them all in Italian, travels to England and joins up with Wyndham Lewis, who was at least a painter as well as being a writer. And then when all that was over, when Marinetti had shot his bolt, Futurism trickled on into the twenties but never got anywhere. As soon as Mussolini began he swamped it. Then you have André Breton, who is also a non-painter, who is the pope of Surrealism.

DC. Actually, it's not so much Breton who comes to mind, in describing Marinetti's activities, as Apollinaire— except that Apollinaire did *after* Cubism what Marinetti did before Futurism.

ELS. Well, Marinetti and Apollinaire were on terms of wary friendship.

DC. They were both riding the same circuit, weren't they?

ELS. They were both riding the same circuit, but Marinetti was much more famous in his own day. Apollinaire was a Parisian figure, Marinetti was a world figure. Of that there's no question. Where they link together, and where they knew that they were linked, was in experiments with what we now call "concrete poetry". Apollinaire's *Telegrammes* are related to, but not the same as, the kind of writing which Marinetti was doing at the same time. There's an extraordinary text of Marinetti's called *Zang Tumb Tumb* which is based on his experiences in the Balkan wars, which is what we would now call a "sound poem", with bullets and bombs going off and clouds of smoke rising and—oh, you name it, he has it.

DC. You said earlier that Cubism, even if it was a dead-end, produced more masterpieces than Futurism. Did Futurism produce any masterpieces? Or any that you would consider even near-masterpieces?

ELS. I don't think so. Futurist paintings always strike me as enormously fascinating documents, and I never

know whether I am looking at them for their documentary interest or their aesthetic interest. Where the masterpieces were produced was by the Russian offshoot of Futurism, Suprematism. The Russians looked both to Paris and to Italy. Vladimir Tatlin, for instance, was in a sense the most distinguished foreign Cubist for a brief moment, especially in the sculptures he made out of all sorts of odd bits and pieces of metal, which are very like Picasso's cardboard collages, but slightly earlier. And you also have the works of Malevich, which are completely abstract works—a black square on a white ground. I think the work of the Suprematists are masterpieces of artistic extremism, but it's never been possible to go beyond those developments in modern art. By 1913-14-15, Malevich had gone just as far as it was possible to go in terms of any conventional format, and I'm using that phrase very broadly in the sense of paint on canvas. The ambitions of the Cubists compared to those of the Russian artists of the same period were really comparatively traditional. And I happen to find the best Suprematist paintings extremely exciting—baffling still, difficult to take still, but very beautiful. Malevich's *White on White* seems to me a supremely poetic idea. It is also, incidentally, a Symbolist idea in the broad sense of the term.

DC. Did the Russian artists benefit from the cultural conditions that the Symbolists enjoyed—exposure to the works of other artists from other countries?

ELS. No, I don't think so. I think by that time conditions in Russia were starting to get difficult.

DC. What year are we talking about?

ELS. We are talking about 1917-18. Of course Larionov had already branched into Rayonism* by about 1912, and Tatlin was painting sort of Cubist pictures about the same time, and Gontcharova was painting very much Futurist pictures at about the same time. But I think that the most extreme abstract works in Russia were painted during and after the war.

DC. *During* the war?

ELS. Well, you have extreme abstract paintings by a lady called Popova which date from about 1917, just when the Revolution breaks out, and the *White on White* composition by Malevich, which I mentioned, was painted in 1918—just at the moment when Russia was least accessible, when politically things were in a state of total collapse.

DC. Are you saying that abstractionism was the natural outgrowth of Futurism?

ELS. No, I think abstractionism was a natural outgrowth of Symbolism.

DC. But surely Cubism and Futurism weren't simply a temporary aberration in the march from Symbolism to abstractionism?

* The abstract movement in painting started in Russia, 1911-12, by Mikhail Larionov and Natalya Gontcharova after lectures given in Moscow by the Futurist Marinetti. According to their theory a Rayonist painting should appear to be in some fourth dimension, floating outside of time and space.

ELS. I would contend that Cubism, at any rate, was just that sort of aberration. You see, what I would call real modern art is concerned with producing not an interpretation of reality but a parallel reality—a separate realm of experience, if I can put it that way. The great Symbolist slogan, "Art for art's sake", means exactly that. Well, that doesn't happen in Paris. That happens, of all places, in Munich. Munich was one of the great continental centers of Symbolist painting, with largely forgotten artists such as Franz von Stuck, who taught Kandinsky. Kandinsky founded the Blaue Reiter, and was the first artist to go wholly abstract. And Kandinsky's plunge into abstraction was very much inspired by Theosophist ideas. He thought that Madame Blavatsky, for example, was a great woman and ought to be listened to very carefully.

DC. So, in other words, Symbolism didn't begin and end with Gauguin—in fact it never ended, it just fell among thieves for a few decades?

ELS. Put it this way. We've agreed in the course of this conversation that one must necessarily think of Cubism as being concerned with reality, reality in its simplest form—tables, chairs, bottles, guitars, newspapers—or single-figure composition at its most complex. In fact, it represented a drawing back from the complexities of meaning of the kind which Picasso had put into *La Vie* and which he put into that picture called *Le Bateleur*, which I suppose translates as "The Mountebank", which is in the Chester Dale Collection in the National Gallery in Washington. But he withdrew from all this. He tried to make painting much more systematic. But abstract

art is not like that at all. People talk, confusingly, of abstract art as being "concrete". We talk about "pure abstraction", the abstraction of Mondrian, of De Stijl. But, in fact, wherever you look at the origins of abstract art, you find metaphysics. Malevich's *White on White* is a metaphysical picture. Kandinsky's early pictures have a metaphysical background. You even find a certain amount of metaphysics in Mondrian, believe it or not.

DC. You certainly find a lot of mathematics.

ELS. But you have this transcendental thing. And of course there is a strongly transcendental current in Symbolism. Symbolism is heavily influenced by people like Schopenhauer, for instance.

DC. And Bergson?

ELS. Bergson is more a prophet of nervous energy, of what he called *l'élan vital*.

DC. I was just thinking that, in a very technical sense, his theories of time and duration—particularly that which happens to perceptions before they become conceptions —seem to have been applied not only by the Symbolists, but by the Impressionists and the Cubists as well.

ELS. I'm sure that Bergson was, as a general philosophical background, very important in modern art. And I am sure that the Bergsonian worship of energy in particular is enormously important to Futurism. One can't read a great deal of Marinetti—and I can claim to have read an enormous amount of Marinetti for various reasons —without beginning to feel that Marinetti was in fact rather stupid.

DC. There seems to me to be a slight contradiction—or at least a curiosity—in the fact that you've said that the high priest of Futurism was stupid, and the painters who carried out his precepts were mediocre compared to the Cubists, and yet you still praise Futurism above Cubism. I hate to be obtuse, but I'm still not clear how Futurism was crucial to the beginnings of modern art in a way that Cubism wasn't.

ELS. I think one can explain this fairly simply. One can, in fact, choose another example from the history of French painting in order to make the point. One of the most difficult moments for the historians of French painting is the beginning of the eighteenth century, because on the one hand you have the exhausted style of Louis XIV, the style of Versailles, the style of Louis LeBrun, and then you have the new style of Watteau, of the *fêtes galantes*, of the informal picture for small rooms, and so on. Well, Watteau is an enormous European success in this case, but he is not the painter through whom the main line of the development of French painting flows. He's oddly isolated. He has immediate followers, like Pater and Lancret, but in fact the tradition flows through Versailles and surfaces again in David. And it surfaces in Vien, who was the first Neo-classical painter. So it is undoubtedly true that a great artist is not always the one who carries the seed by which art reproduces itself. The mediocre artist may be more fertile for those who come after him. I think my contention about Futurism would be that Boccioni and Balla are both painters of very considerable talent. I don't want to write them off. I would very much like to live with a masterpiece

by one or other of them, and I think they did produce occasional masterpieces. But their work doesn't seem to me to have the perfection of the best Cubist canvases of either the analytical or synthetic period. On the other hand, this lack of perfection left possibilities open which succeeding artists could exploit. It was always possible to see what you could do with what they had left undone. Cubism is very skillful but closed, claustrophobic even. It fulfills its own premises so very well, so very skillfully, with such devotion, that it's hard to see how it could continue. The only possibility is a revolt, and essentially that revolt is Surrealism, which completely throws over all the Cubist discoveries. It throws over all ideas about the integrity of the painter's surface and goes right back to illusionism. And it goes right back to academic technique in the case of Salvador Dali. Also, one does have this feeling that Braque and Picasso are the only two successful Cubists. Even Léger won't quite do, and Gleizes and Metzinger won't do.

DC. And Juan Gris?

ELS. Gris is an artist about whom I have very divided feelings. Personally, I find his work very dry. I think those pictures by Gris in the early twenties have a perfection, but it's an extremely sterile perfection to my mind. It goes nowhere. What can you think of which derives from Gris? Nothing. While I can think of plenty which derives from Futurism, and plenty which derives from the Russians and De Stijl and all the rest. But basically art hasn't gone the way of the Cubists. It's gone in the direction of metaphysics, and the direction of meta-

physics was the direction pointed by Russian Futurism.

DC. Couldn't that be partly as a result of the fact that the Russians were painting during the war, which wasn't the case in Europe apart from Gris and Picasso?

ELS. Who were both Spaniards, yes. Whereas art did manage to keep on during the war in Russia. I think it also managed to some extent in France.

DC. At any rate, the war did have a devastating effect on European art.

ELS. Well, it smashed up the old unified world in which Symbolism had flourished. It made people very worried about the state of culture. It depressed them. It made them react into anti-art, which is really what Dada is about. Dada was made by a group of refugees who had gone to Switzerland to get away from the war. And I think that undoubtedly the war changed the atmosphere in which art was made and cut short many of the developments which we have been talking about and prepared the ground for new ones. It's a case of political events also marking a definite artistic divide. One does feel the old world going smash. And one also feels in a way, looking at the extremes reached by Malevich in 1918, that the smash was inevitable. Just as one feels, when one reads Marinetti, with his worship of violence, that there was a definite sort of lemming-like urge toward self-destruction, and that the birth of modern art was as much a destructive as a constructive process.

DC. And in that sense you see Cubism as the destroyed rather than the destroyer?

ELS. Yes, I do. To me, Cubism is Naturalism's last gasp. I know that I am using Naturalism in a rarefied sense. Many people would say a possibly perverted sense. But I think it's the last time that artists were able to feel that art could make observed reality its business—that the connection between what you put on canvas, or what you carved in stone, or what you cast in bronze, and what you actually saw going on around you was too clear, too well-defined to be worth questioning. I think it's the moment before the realms of life and art finally separate. Symbolism had made this separation a point in its program, but had failed to establish absolutely for its contemporary public that this was in fact true. And since the whirligig of time brings its revenges, as the poet says, the point was established afterwards, after the Cubists had had a try at proving the opposite. I feel that this confidence in what was real, what could be touched, what you could run your hand around, what you could walk around and look at, was never to return. I think it was one of the things which crashed with the war. The war's experiences were so horrifying that they made men doubt their senses. You get this curious back-and-forth reaction which you can examine in the poets. On the one hand you have Apollinaire exclaiming, *"Dieu, que la guerre est jolie!"* "How splendid war is!" And on the other hand you have English war poets like Wilfred Owen saying that "the poetry is in the pity". But it is quite clear that for many people the only way of over-coming, of absorbing the experiences of war was to turn to something transcendental. The alternative was to turn back to a much more narrowly defined kind of traditional-

ism. I find it deeply significant that Picasso, after the Cubist experiment, turns to Neo-classicism. He looks back beyond Puvis to Ingres and to David. He does the most traditional thing that he can think of for a few years, almost as a way of getting his breath back, of reaffirming values. And one does see in the immediately post-War world a drawing back from modernism in the general sense. And yet at the same time is it too much to say that Picasso's Neo-classicism has a camp element, a send-up element? One already sees that this gnawing doubt about the connection between art and reality had implanted itself so deeply that Cubism itself could never return. I think it is the last gasp of the nineteenth-century confidence that the world was one and that the world inside the head was the same as the world which the finger touched.

II
Surrealism / Dadaism

DC. Since Surrealism began, like Symbolism before it, primarily as a literary movement, let's begin by discussing how this came about.

ELS. Surrealism began as a movement in the Paris of the immediately post-War period and was in part inspired by the reports which had been coming into Paris from Zurich of what was going on there.

DC. The Dadaists?

ELS. The Dadaists. Dada itself started in 1915 and is historically very interesting as the first anti-art movement on record, the first movement whose premises were almost entirely negative. Of course the reason for this negativism is easily guessed at: it was the consequence of the First World War. The whole of society was toppling and neutral Switzerland was a place where a little band of exiles, mostly German, had gathered together, and their determination to pull down the edifice of art was

parallel to the politicians' determination to pull down the edifice of Europe itself.

DC. More specifically, where can we say Surrealism began? With André Breton?

ELS. Well, it really began when Tristan Tzara came to Paris immediately after the war, when travel was possible again. There was a brief period between about 1918 and 1921 when the Dadaists, who were mostly foreigners coming into Paris, and the Surrealists-to-be, who were mostly native Frenchmen, lived together. Eventually the Surrealists revolted against the visitors because their sort of French logic, oddly enough, was offended.

DC. I can understand that. I have always been struck by the fact that for all its jokiness, for all of its almost planned silliness, there is in fact a plan to Surrealism. It is terribly programmatic. It reeks of French aestheticism —if not of the Gaston Bachelard* type, of a new type.

ELS. I think the situation was that Breton, who was to be the pope of the Surrealist movement, the central figure, was in any case a man of extremely dictatorial temperament, a man who couldn't bear not to be dictatorial.

DC. The word "pope" is very apt, because he was always excommunicating people.

ELS. Yes, the history of the Surrealist movement, as written by Maurice Nadeau, is a series of schisms and excom-

* Distinguished French critic, author of *Poetics of Space*, *On Poetic Imagination and Reverie*, *Philosophy of No: A Philosophy of the New Scientific Mind*, among others.

munications. But what Breton brought to Dada, his contribution, was his knowledge of Freud. And his idea was that Dada irrationality could be used to plumb the depths of the unconscious mind, that it was a way of throwing the mind out of gear and getting at truths which lay hidden behind reason.

DC. The "creative unconscious".

ELS. The "creative unconscious" and all the rest of it. And of course the veteran Dadaists didn't see things in this way at all. The other idea which the French Surrealists brought to art was the idea that revolution in art and political revolution were necessarily linked—which hadn't, I think, been worked out by the Dadaists to anything like the same extent. On the whole Dada was anarchic, while Surrealism looked for an alliance with a political creed, to wit Communism.

DC. They had a very uneasy and variable history of relations with Communism. Some went into the Party; some, like Breton, compromised and became Trotskyites.

ELS. And others renounced Surrealism altogether in favor of Communism—like Louis Aragon, who is, of course, the great deserter from the Surrealist movement. He went to Kharkov to a literary conference in 1929, as far as I remember, and returned a convert and I think finally broke with Surrealism in 1931.

DC. Was that when he formally joined the Party?

ELS. Well, he published a poem in France called *Front rouge*—"Red Front"—which was, among other things,

an incitement to the workers to rise against their masters. And he was prosecuted, I think, for encouraging soldiers to desert. Anyway, he was prosecuted for attacking the security of the state, and he was rather half-heartedly defended by Breton. But Aragon found Breton's defense more insulting than the prosecution itself, and this was really when the split came.

DC. What was Picasso's relationship to Surrealism at this time?

ELS. Picasso was gradually attracted toward the Surrealist movement in the late twenties and became the most distinguished recruit which Surrealism ever had from among established artists. He started by making a series of drawings which were defamations of his Neo-classical style, in which the forms were pulled out and distorted so that they became overtly sexual. The figures became made up of sexual bits and pieces—of penises, of vaginas, of breasts, and so forth. And then he proceeded to use this new style of biomorphic Surrealism as the basis for all the pictures which he produced in the thirties. It is, indeed, the basis of *Guernica*, which is Picasso's great political masterpiece, painted in protest against a bombing raid in the Spanish Civil War. Picasso was, of course, very much on the Loyalist side against Franco, and has remained so ever since.

DC. In fact, this eroticism which you mentioned is a fairly constant thread running through Surrealist work in the twenties, wouldn't you say?

ELS. Well, it's a constant of all Surrealism because since

Surrealism takes off from Freud, the assumption is that the erotic component is the deepest and the most important. You see, Surrealism has this constant tension between the stress on individuality, on discovering the possibilities of the individual, and the desire to cooperate with others in making a revolution which will overthrow bourgeois society. Breton finally found a convenient way out of this by aligning himself with Trotsky in the thirties and becoming a Trotskyite. But his assumption that the revolution in art was equivalent to the revolution in politics has bedevilled modern art ever since. There is no proof that I know of that these two kinds of revolution really go hand in hand. It's just that artists have been led to believe that it ought to be so. And I think that the history of modern art in a political sense is a comedy of misunderstandings which continues to this day, with the Maoist outcries of the avant-garde, the Guevarist outcries of the avant-garde, when we know perfectly well that the avant-garde, as Europeans understand it, has never been comfortable under any kind of Communist regime. The closest it has got to it has been in Cuba.

DC. And art has always been the least revolutionary, and the most retrogressive formally, when it has been produced under the aegis of a Communist regime.

ELS. It depends on the way you look at it. All anti-bourgeois regimes, if one can put it that way, assume that art must be one of the servants of the state and must communicate social truths, and must communicate them efficiently. Therefore it must use a visual language which everybody understands. To the Surrealist this is

an intolerable burden, because it means that he is not free to see what form art will take if he allows it its own head. The difficulty is really in trying to link the two great prophets of our time, Freud and Marx. Freud, as you know, was the product of a bourgeois society—that is, pre-1914 Vienna—and it has often been pointed out by his less orthodox followers that his assumptions are very much rooted in a stratified bourgeois society, and that Freud's idea of what is normal—which I think is a question that psychoanalysts increasingly ask themselves—is based on a bourgeois normality.

DC. It's also based on his almost exclusive preoccupation with that which was abnormal. I've often heard it said that the trouble with Freud is that he never met a healthy man.

ELS. I don't think that's quite true. I think the difficulty is that normality is a shifting concept, that normality is that which is acceptable to the society of your time, and the business of the analyst working with the patient is on the whole to bring the patient to a state where he or she can fit not too uncomfortably into the framework of social conditions then existing.

DC. Which, of course, is absolutely contrary to the political concept that you should change the social conditions to adapt to the needs of the individual.

ELS. Precisely. Also, you see, you get in Surrealism a recurrence of the emphasis on Romantic individualism. It's what the individual finds inside himself which is the most important thing and which must dominate all

others. And of course this is intolerable in a planned society, which is what the Marxist looks for.

DC. It's interesting the way Freud was adapted and taken over by the Surrealists, because I remember when Freud was dying Salvador Dali came to visit him in London and Freud said to him, "What interests me in your art is not the unconscious but the conscious." Now of course that could have been a big joker pulling the leg of a little joker.

ELS. Let's look at that remark for a minute, because I think it offers us a lead into describing what Surrealist pictures really are. The fascinating thing about Dali's work, and also the disconcerting thing, is that it is painted with all the resources of nineteenth-century academic technique. It uses exaggerated perspective, it uses illusionism, it uses very carefully planned imagery. There is no room for accident in a Dali picture. It must all have been pre-planned. And in a sense this seems to go against what Breton demanded of the poets under his charge. As you know, the great Surrealist literary method was that of automatic writing. You sat yourself down in front of a blank sheet of paper with a pen or a pencil in your hand, and you made your mind as blank as possible, and then, the theory was, the hand wrote without conscious dictation. Now, the Surrealist painter of the thirties didn't work that way at all. It's quite clear that he had already formed a concept of the fantasy he wanted to put down and that little alteration was possible. The principal Surrealists of that time are on the whole not what we call painterly painters. But if you look to

the Belgian Surrealists—Magritte, for example—you find the driest, the least painterly of all modern artists.

DC. The wittiest, too.

ELS. And probably the wittiest, but Magritte's wit is based on his literalism. He paints everything in an absolutely straightforward academic style. It's the way that the images are fitted together which makes the pictures bizarre.

DC. I'd agree that Magritte is probably the supreme example of realism within Surrealism, but wouldn't you say that Surrealism *implies* realism, in the same way that metaphysics implies physics? In other words, there is an internal dialectic going on in Surrealist paintings.

ELS. Well, there are three different kinds of Surrealist art under the same umbrella. I think this is extremely significant because it tends to show that Surrealism is not a matter of artistic commitment—that is, technical commitment, as Cubism was—but a matter of intellectual commitment.

DC. It's a whole new aesthetic?

ELS. It's an aesthetic which is in fact a revival of Symbolism in many respects. Just as the Symbolists were anti-realistic, were against the Naturalism of their time, so the Surrealists to some extent revolted against the notion of art as a closed shop, as a thing which happened on the canvas and had no consequences for anything outside it. There's a strange reversal here, you see. "Art for art's sake" is such an ambiguous phrase. The Surrealists, who

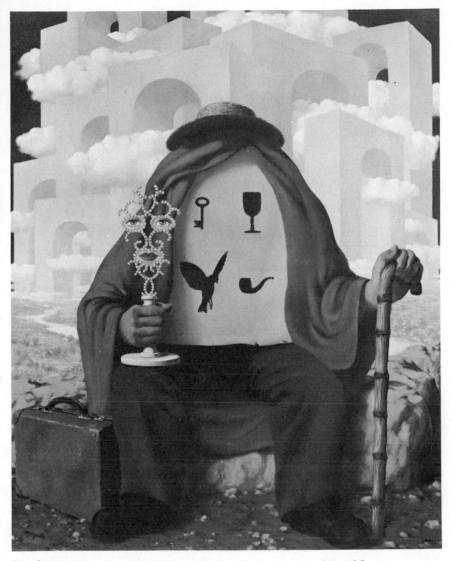

René Magritte, *The Liberator,* 1947, oil on canvas, 31 x 39 in. Los Angeles County Museum. Gift of William Copley.

were the heirs of the art-for-art's-sake Symbolists, revolted against the art-for-art's-sake of Cubism, if this is not logic-chopping too much. But I think one can distinguish at least three different kinds of Surrealist painting. One is the magic realism of Dali, where you have a representation of objects which are distorted, but which are nevertheless recognizable objects painted illusionistically.

DC. A limp watch is still a watch.

ELS. Yes, and a grotesquely distorted limb with a crutch underneath it is still a grotesquely distorted limb. One finds similar images in Bosch, for example, at the beginning of the sixteenth century. Then you have what is called biomorphic Surrealism, which is the kind Picasso practiced, which takes this distortion of limbs, this distortion of parts, and tries to show you nature in a state of transformation: growing, swelling, tumescent, and that kind of thing. You find this in the work which Jean Arp did in the thirties. You find it in the work of Henry Moore, where the sculptured figure often becomes a metaphor for the landscape—figure and landscape become one. You find it in the work of a painter like Yves Tanguy, where the forms, instead of alluding to objects in the real world, as Dali's do, take on an independent life of their own. And then finally there is what one might call calligraphic Surrealism, which is to be found in the work of André Masson. But these classifications tend to leave stranded the most important of all Surrealist painters as far as I'm concerned, who is Max Ernst.

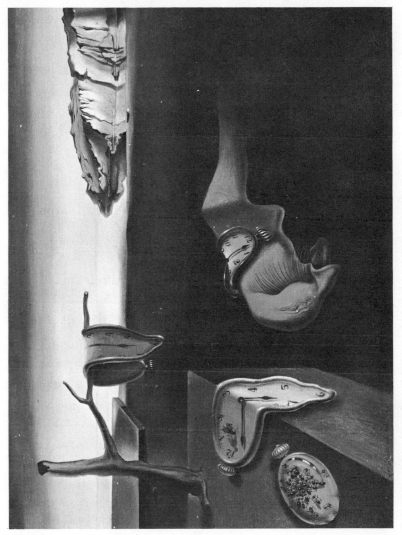

Salvador Dali, *The Persistence of Memory*, 1931, oil on canvas, 9½ x 13 in. Collection The Museum of Modern Art, New York.

DC. Who also was originally one of the Dadaists.

ELS. Yes, Ernst started as a German Dadaist, not in the Zurich group, coming straight to Paris from Germany. And of course Ernst is the inventor of the nearest technique in painting to automatic writing, which is the use of *frottage*. What Ernst would do was to take a leaf or a bit of wood with a strong grain, or any small object, perhaps a piece of metal mesh, and he would put a piece of paper over this object and then he would take a soft pencil and rub it over the object and a pattern would emerge. And this pattern would in turn suggest an image, and this image would be built up into a picture. All those forest-like pictures which are so characteristic of Ernst, those strange landscapes, arise originally from *frottage*. Ernst was also, of course, the man who extended *collage* very much by turning to old engravings and chopping them up to form new compositions. The Surrealists were always very happy to use "found material".

DC. I suppose Kurt Schwitters was the grandfather of them all, because he used everything he ever found.

ELS. Yes, Schwitters was a magpie. Schwitters's gift was for taking rubbish, literally, the detritus of the industrial world—bus tickets, little scraps of wrappers and so on—and constructing exquisite small compositions with them. I once heard them described, in Marianne Moore's phrase, as "imaginary gardens with real toads in them". Schwitters also, of course, tried to control his own environment by turning the places he lived in into vast *collages*. He was the inventor of what we now call the "environment" in the art world. He called such compositions

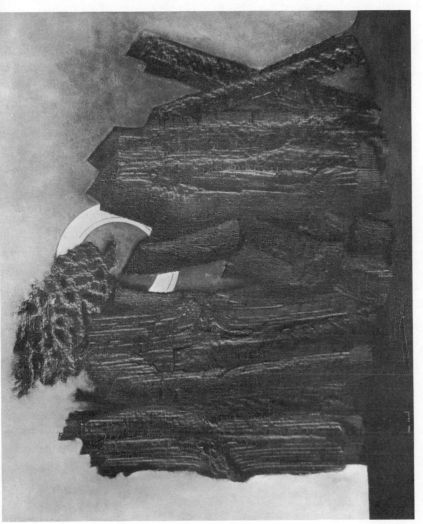

Max Ernst, *Forest*, 1926, oil on canvas, 28¾ x 36¼ in.
Collection The Museum of Modern Art, New York.

merzbaus. Merz was an invented word; *bau* is of course the German word for "build". He was a bit like a caddis worm. You know, the caddis worm lives in the pond or the stream and gradually builds a shell around itself from the materials which it finds. If you put a caddis worm in a tank full of beads, then it will build itself a tube of nothing but beads. Schwitters had this compulsion to build around himself this very strange environment which was the reflection of his own fantasies.

DC. Giacometti was also doing Surrealist work at this time, wasn't he?

ELS. If we are going to talk of Surrealist sculpture, I think that Giacometti is arguably the most distinguished Surrealist sculptor of them all. He didn't make a very large group of works, because he was younger than the original Surrealists, and this group which he made dates mostly from the thirties. But it includes a number of enormously fascinating and seminal works, including the *Woman With Her Throat Cut*, which you may remember. To me it has always looked like a dead praying mantis. It looks like the shell, but blown up to a vast scale. The idea, I think, is that it's a woman who has been violated, as Jack the Ripper violated his victims. And I think one of the things which one does see in this kind of work by Giacometti is a very strong component of aggressiveness in Surrealism. That was inherited from Dada, but Dada and Surrealism between them continued the tradition of aggression which had been inherited from the Fauves, and indeed it had been inherited from the Russian Futurists.

DC. Of course with Breton acting as cheerleader they could hardly fail to be aggressive.

ELS. Well, the whole idea was *épater les bourgeois*—to make the bourgeoisie unhappy about the situation, to rattle them so to speak. But of course this involved the making of special claims on behalf of the artist.

DC. Where was Giacometti working at that time?

ELS. In Paris, and then he had an infertile period in Switzerland at the beginning of the war. He was Swiss, as you know, despite the Italian name, and his father was a distinguished Symbolist painter.

DC. You've mentioned the aggressiveness in Surrealism. Even more significant, it seems to me, is the element of humor, because this is really the first time when humor becomes a major discipline in art.

ELS. It was black humor. The ancestor of that kind of humor is Alfred Jarry, the inventor of the monstrous King Ubu, who shouts *le mot de Cambronne*, as the French rather charmingly call it, after one of Napoleon's generals. That is, he shouts *merde* at the world, and behaves in a way in which the Id is supposed to behave when uncontrolled by the Superego. Jarry's jokes are always cruel jokes. We laugh at the awfulness of it all, and doubtless this is what the Surrealists inherited, this kind of passion for destruction.

DC. But there's also a great deal of playful humor running through Surrealism.

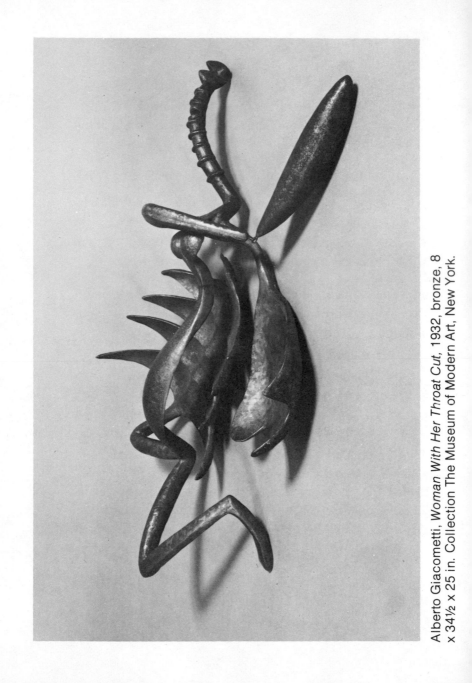

Alberto Giacometti, *Woman With Her Throat Cut*, 1932, bronze, 8 x 34½ x 25 in. Collection The Museum of Modern Art, New York.

ELS. I don't find Surrealism so playful. The Freudian view, of course, is that everything said in jest conceals a truth—that if you say to somebody laughingly, "I'd like to kill you", there is a little bit of you which would really like to kill them. And I think one of the things which you find particularly in biomorphic Surrealism of the Picasso kind, and in fact specifically in Picasso even more than any other artist of that sort, is an assault upon received reality. The figure is torn apart, is violated, is even made obscene if you like. So the process of creation in the work of art is balanced by an urge toward destruction. You remember, for instance, that in Indian art there is the legend of Kali, who is at once the creator and the destroyer who dances, and. as she dances men are destroyed and men are made. Well, I think there is something very like that sort of dynamic in Surrealism at its best. It is very difficult, I think, to talk of an achieved work of art with Surrealism, because there's always something incomplete, something is being smashed up or broken down at the same time as something is being made, and this somehow offers a way of entry for the imagination. The best Surrealist works are enormously suggestive, simply because you are forced to supply something. You must bring some part of yourself to a great Picasso or a great Ernst. You must give something. Your unconscious has to mate with the unconscious of the artist. And that, I think, is why the best Surrealist works have survived so very well and why they are coming back into fashion. All these movements of the Dada-Surrealist kind, of course, responded very much to circumstances. Take those Zurich Dadaists who went back

into Germany, the collapsing Germany of the period immediately following the First World War. Heartfield —or Herzfeld as he was before he anglicized his name to John Heartfield—was a maker of political *collages* which have survived as some of the most savage testaments of the political situation of Germany in the twenties, and indeed are among the few works of extreme avant-garde art which are smiled upon by the present East German government. It's their political content no doubt.

DC. Which overrides their technical achievement.

ELS. Exactly. In Paris, on the other hand, Surrealism didn't take that particular road, but became fashionable. It became part of the chic world. In the late thirties, when Schiaparelli was the leading couturier in Paris, she was making Surrealist-inspired clothes. In fact, I remember a photograph of a Schiaparelli costume of that period where the lady is wearing a vast shoe on her head. And of course you have this obsession with the word "shocking" in Schiaparelli promotions. This is the concept of the *épatant* carried into the world of chic, even including the use of unsuitable materials—couture clothes in hessian and that kind of thing. In fact Surrealism became very, very fashionable in the thirties in France, and to some extent in England. And that fashion filtered through and inspired quite a number of things which we now take for granted, such as shop-window displays. The kind of display we accept as very much run-of-the-mill nowadays wouldn't have its element of irrational fantasy but for Surrealist invention. The same is equally true of advertisements. The way in which adver-

tisements are put together, the way in which images and words are welded, the way in which one image short-circuits another to make the best use of the space—all that comes from Surrealist painting. It has percolated down and become vulgarized.

DC. To a certain extent, also, underground movies are an offshoot of Surrealism.

ELS. Well, the first underground movies were, of course, *Un Chien Andalou* and *L'Age d'Or*. One is Dali and Buñuel, and one is Buñuel. And some of the finance for those movies came from Count Etienne de Beaumont, who was the great promoter of avant-garde art in the fashionable world in Paris, and they were made as a statement against the pomposity of the film as it then existed.

DC. So one can safely say that Surrealism has had a large effect on films?

ELS. Indeed yes, because those two films are absolutely seminal. The whole idea of the free cinema, of the cinema with its own grammar, as opposed to a grammar based either on what would happen in reality or what would happen on the stage, springs from those two movies.

DC. We've talked a lot about France and Germany. What was going on in the other countries at this time? In England, for example.

ELS. In England you have, first of all, an attempt to catch up with what was going on on the Continent.

DC. And who was doing the catching?

ELS. Well, essentially there are two groups. One is a group of Surrealists of whom Moore was the most distinguished, and the other one is a group of abstractionists led by Ben Nicholson. One can say, I think, that there was very little going on in English art in the twenties, though it's a subject which is so obscure that a good deal of research remains to be done on it. Surprisingly little is known, despite the fashionable success of the Bloomsbury group who dominated English culture in the twenties.

DC. Virginia Woolf's group.

ELS. Yes. Virginia Woolf's sister, Vanessa Bell, married to the art critic Clive Bell, was a painter, and was in fact one of the most distinguished English painters of her period. It's the group of Roger Fry, Clive Bell, Vanessa Bell, Duncan Grant which is of prime importance in the England of the twenties. But I think we understand very little about what happened to English painting immediately after Vorticism. Vorticism collapsed with the outbreak of war. It was a very brief, very intense avant-garde movement. Fry and Bell, who were obsessed with Cézanne, were obsessed with the superiority of French painting. Bell once committed himself in print in the *New Statesman* to saying that a first-rate English painter would never be much better than a second-rate French one. Out of this situation there then arose almost a class revolt. You must remember that while Bloomsbury was very upper middle-class, Henry Moore, for example, was of working-class origin. Nicholson wasn't—Nicholson came from a dynasty of artists. But

there arose a revolt against the view that British art could never be any good, and you have a moment in the thirties when the refugees are starting to arrive—when Gabo arrives in England, and so forth—when there is a good deal of activity, but most of those refugees then go on to America.

DC. Yes, New York during the war probably had more Surrealists than Paris did at any time.

ELS. But people are now beginning to remember that there was a moment in the thirties, around the big Surrealist exhibition of 1936, when it did seem as if there was going to be an important Surrealist movement in England. You had painters such as the young John Armstrong and Tunnard at work here, but it all petered out because of the war. So Moore is not only the most talented, but the only great survivor. There's been a huge massacre somehow of artistic talent in England.

DC. What about America?

ELS. Well, in America you had quite a variety of things. You had painters such as Stuart Davis, who was influenced by Cubism but who in a curious way foreshadows pop art in his use of ordinary objects. You had a few very distinguished pictures by a very uneven artist called Joseph Stella, and then eventually, when the Depression set in, you had a return to realism on the part of painters like Edward Hopper. But social realism was almost as fashionable in America as it was mandatory in Russia. Russian art, as you know, had the Constructivist movement, but when the Stalinist clampdown came toward

the end of the twenties Constructivism was very much debilitated. People had lost faith in the easel picture as such in Russia. The avant-garde had lost faith, and it was very easily moved over by the political authorities to give place to an approved kind of socialist realist art—what we now call "tractor art"—of which there are one or two not bad representatives of that period. There's a painter called Deineke, for instance, whom the Soviets sometimes send us when they want to show Soviet achievement in the arts, and it must be said, despite one's prejudices against the clampdown, that Deineke is a distinguished artist.

DC. So, to paraphrase Marianne Moore, Surrealism in Russia was a toad in a garden of tractors?

ELS. Well, there was no Surrealism in Russia, actually. Realism without the "Sur" is the only thing you get.

DC. In that case let's go back to America. Did Surrealism ever take root in America? Or was it grafted on to the social realism of the thirties?

ELS. Well, Dada took root in America. There was the circle around Stieglitz, and of course Marcel Duchamp spent a lot of his time in New York.

DC. And Francis Picabia.

ELS. And Picabia spent a lot of his time in New York. But I don't think Surrealism ever managed to make itself into the force which it was in Europe. The Surrealist impact in America was delayed until Breton's arrival as a refugee in 1940. Undoubtedly the presence of a group

of distinguished Surrealist exiles in New York, centered around Peggy Guggenheim's "Art of This Century" gallery, made an enormous difference to the development of American art, a really enormous difference. Suddenly possibilities opened up which had never been there before for American painters. You see, what happened in America during the thirties was that there was a very strong current of influence from Mexico, from the Mexican muralists—Diego Rivera, Siqueiros and so forth —and in fact Rivera executed a number of important commissions in the United States. At the same time, because of the slump, the Works Projects Administration was dealing out large mural commissions to artists. Many of them are now painted-over and lost. For instance, Arshile Gorky painted an enormous mural at Newark airport which has since been painted out. And there was a very strong feeling in America that art ought to show social responsibility, that the Mexicans had found a way for art to connect socially, and in fact I think modern artists were under strong pressures in America in the thirties, just as writers were, to conform to notions of social responsibility.

DC. Which was a hostile climate for Surrealism to grow in.

ELS. Indeed yes. And these pressures came from the Left as much as from the Right in America.

DC. If not more so.

ELS. Yes, one of the things which has been a little bit glossed over, because of people's hatred of what

McCarthyism did after the war, was that the American intellectual circles of the thirties were much more doctrinaire in their belief in Communism than similar circles were in England.

DC. You mean the *Partisan Review* crowd?

ELS. Exactly. There was a moment when one could speak not merely of American Communists, but actually of American Stalinists. And I think if you read the memoirs written by the mavericks of that period, like Edmund Wilson and Dwight Macdonald, you see that there was considerable pressure to conform in this way. It wasn't a good climate for experimental painting at all.

DC. Well, Duchamp was there. How would you place Duchamp in the history of Surrealism, or Dadaism, or any other "ism"?

ELS. Duchamp was never a Surrealist.

DC. I suppose he was never an "ist" of any kind, was he?

ELS. Yes, he was a catalyst. That I will grant. But I think that one of the things you've got to say about Duchamp is that he wasn't in fact a very great visual talent. He did have a piece of good luck at the Armory Show in New York before the war, when his *Nude Descending A Staircase* was the hit of the show. Somebody unkindly described it as looking like an explosion in a shingle factory. But you must remember that Duchamp really abandoned painting in favor of other forms of activity. I think he's best described as a "laughing philosopher"

in the sense that the Greeks would have used that phrase. His whole concept of art was that art was not necessarily a making of something, but simply an activity which would make people think, which would shake up the universe a little, which would alter the configuration of things. So that when he showed a urinal, signed "R. Mutt", in an art exhibition, I think he really wanted to make people think about the criteria we apply when we say, "That thing is a work of art."

DC. He's always appealed to me because, unlike Picasso, he's never loomed over modern art, he's always lurked.

ELS. Yes, I think that's a very good description. Of course the principal instruments of his lurking, if one can put it that way, were the "ready-mades", like the urinal. That is, things found in the surrounding environment and presented as works of art. The idea became that you didn't shape a work of art as the potter shapes clay, you simply went out and chose it. And this is, of course, a seminal idea as far as post-War art is concerned. But it's very difficult to place Duchamp in any kind of artistic context, and I think that he deliberately chose this role. He was very secretive. It was supposed, for example, that he'd virtually given up work after making the large glass, *The Bride Stripped Bare By Her Bachelors, Even*, which is an extremely complex piece of sexual and chance imagery. And yet after he died it was discovered that he had been working on almost a kind of *merzbau*, on a huge room, for years and years without telling anybody about it. He was a very private man, and in a sense his privacy was also important.

DC. Another private man who was in New York at that time is a painter we haven't mentioned so far: Chagall.

ELS. Chagall is an example of the independent artist. We've been talking about movements. We've been talking about Surrealism. We've been talking about social realism. We've been talking about Dadaism. But you've got to remember that the period between the wars was quite a good period for the independent artist. You have someone like Chagall, who begins in Jewish Russia, whose imagery is supplied by his childhood, who tries to come to terms with the Revolution, but who eventually leaves Russia in 1923 never to go back again. He is attracted in the first place to Paris by a commission from Vollard to illustrate Gogol's *Dead Souls*, and then he is able to exist as a painter and to some extent to develop totally independent of all movements. It's true that those floating lovers with bouquets and that kind of thing do have a superficial resemblance to Surrealism, but I don't think anybody has ever tried to count Chagall as a member of the Surrealist movement.

DC. Speaking of those floating lovers, it's always seemed to me that ever since the thirties Chagall has been painting the same picture over and over again. Is that a fair comment?

ELS. I think it's a very fair comment. But Chagall isn't the only independent, and to my mind is not by any means the most distinguished independent, in Paris between the wars. Picasso and Braque are there, for example. Picasso is always jumping from one thing to another,

one period to another. He goes Cubist. He goes Neo-classical. He goes Surrealist. Braque, on the other hand, simply begins to develop Cubism in accordance with the established traditions of French painting. That is, he relaxes many of the rules. He goes back to color. He makes a great thing of texture, of what the paint will do for you, of what they called *la belle matière*. And he therefore establishes himself in a totally independent position. And yet, at the same time, he is undoubtedly painting masterpieces. I am thinking of the picture he painted for Count Etienne de Beaumont, whom we've already mentioned, which is a tall, thin picture of a still life on top of a pillar—a very odd kind of composition, and yet it works triumphantly. And this is a masterpiece, above all, of professional painting, of professionalism, of knowing how to do it. Another independent is Léger. Léger begins as a Cubist, and then develops his own version of machine imagery, very different from Futurist machine imagery, and becomes obsessed with the idea of work and the working class and so on. He isn't a socialist realist painter, but he does show that the demands of the modern world can be reconciled both to modernism and to classicism. He is a Poussin of the construction worker, so to speak. And while those developed pictures of Léger's in the thirties do have lacks —they have very little interest in texture of paint and so forth, and one can see them as rather dry—they are undoubtedly impressive contributions, but impressive contributions from an independent standpoint.

DC. Where would you place Miró?

ELS. Miró is really a Surrealist—a calligraphic Surrealist above all. What you find in Miró, Miró's great invention I think, is that he was the first person to explore the idea of the pictogram, of the picture being made up not so much of images as of signs that refer to images.

DC. Thinking of pictograms, what about Man Ray's "rayograms"?

ELS. I am always a little doubtful about Man Ray as a major figure, either in photography or indeed in art, because I am always a bit worried by the tendency of photography to go arty. One of the ways in which art has tried to defeat photography, to win back its place as the dominant medium of visual information, has been by tempting the photographer to try to do things which the artist does better. Photographic *collage* seems to me a medium which presents grave temptations and dangers to anybody who embarks on it. And my own personal preference has always been for the straightforward photographic image absolutely undoctored. That is, I am on the side of Cartier-Bresson.

DC. Where would you place Paul Delvaux in the three categories of Surrealism?

ELS. Well, he is very much related to Magritte, with more fantasy and I think a much greater degree of sentimentality and a rather narrower range of subject matter. He's the artist in whom you see most clearly the relationship between the Symbolism of the nineties and the Surrealism after the war. That is, there is a very, very strong link between Delvaux and an artist like Fernand Khnopff,

for example, who was the leading Belgian Symbolist.

DC. We've been talking about the relationship of independent artists to the Surrealists and to Surrealism. What about the relationship of Surrealism to literature, or music, or the other arts?

ELS. I don't think there's any such thing as Surrealist music. There was such a thing as Dada music, perhaps, invented by Erik Satie. Satie's passion for the banal and his black humor, which is very like Jarry's, do make him an important figure. In fact, considering how slight his work is, it's surprising how seminal he's proved to be. But what one looks at in particular is one of the most famous of all the Diaghilev spectacles, the ballet *Parade*, for which Satie wrote the music and Picasso designed the costumes. You have an odd conjunction in that entertainment, which was really a kind of Dada entertainment upgraded for the rich. You have a strange conjunction of Cubist decor and Dadaist musical intentions. But in fact the strongest strain in the music of the post-War period in Paris is Neo-classicism. Stravinsky abandons his primitivism, the primitivism of *Les Noces* and *Le Sacre du Printemps*, and writes things like the ballet *Apollon*. And Satie's successors are, oddly enough, Neo-classicist as well. They are the composers called *Les Six*, which include Milhaud, Auric and notably Poulenc. And you have there an attempt to reconcile music to the necessities of the fashionable world, if I can put it that way, to make a kind of music which was modern and at the same time approachable. The other alternative is presented by Olivier Messiaen, who

writes these enormous works as opposed to the rather concise works of composers like Poulenc, which have a kind of Romantic, Expressionist cast. But Paris isn't really the most important center for music. That, I think, remains Vienna. It's Schoenberg, Webern and Berg who are laying the foundations for the music of the future at that time. But there what one has to recall is that the more serial music becomes also the more disciplined it becomes. Schoenberg in particular is an example of an artist who moves from very subjective music, Expressionist music, music without strong frameworks, free music, into totally controlled music. The difficulty is, of course, that as music became more difficult it lost its following. And I think people were already very concerned about that in the late twenties and thirties. One solution which was proposed in Germany under the pressures of the political situation was the one proposed by Brecht and Kurt Weill, which was to make over the jazz idiom so that you had a respectably disciplined and composed kind of music, which at the same time was comprehensible to the general public.

DC. And also had a message.

ELS. And also had a message. But Weill based himself not only on jazz but on the German cabaret tradition. And of course the political situation was so desperate by the time things like *The Threepenny Opera* came to be written that this urgency tended to forge a kind of music which would serve. When Weill goes to America and starts writing musicals without Brecht, his music is clearly much less distinguished. He's very much a

composer for an occasion. There's no comparison in quality, to my mind, between his American musical *Lady in the Dark*, which starred Gertrude Lawrence, and the songs written for *The Threepenny Opera* or *The Seven Deadly Sins* or things of that kind.

DC. So in fact this is simply the musical equivalent of the pressure of reality that was bursting in on "surreality" in painting at the same time?

ELS. Yes, I think that's a good point to make, because what it implies, which I think is quite right, is that Paris was a protected environment, that despite the political troubles which disturbed the public during the thirties it was still a protected environment for artists, and that was one of the reasons why it was so importnat. But art did have a bad time between the wars in many respects. It was struggling against the current of world events, and even where you didn't get direct suppression of modern art, as you did in Russia and then of course after 1933 in Germany, you got a kind of flagging of energy. This is particularly true of Italy, where there had been, for example, such exciting things before and just after the war we haven't mentioned Giorgio di Chirico and *pittura metafisica*, for instance, which is another kind of foreshadowing of Surrealism—and yet in the late twenties and thirties in Italy nothing much happens, even though the regime was not by any means as repressive to artists as the other two totalitarian regimes in the Europe of that period. Although one doesn't get in the thirties a narrowing of horizons, the possibilities for artists become fewer instead of becoming, greater. And there's a great

difficulty for artists in America in that the American public has a snobbery about foreign names. On the one hand, if you weren't foreign you weren't avante-garde, so American artists got neglected. And on the other hand if you were foreign, people were suspicious of you and you might get neglected as well.

DC. Nevertheless at this time America was producing quite a substantial avant-garde in literature. Why didn't their painting keep pace with their advances in literature?

ELS. It's a puzzling question. It's quite true that you have not merely an expatriate avant-garde of American writers, among whom were Gertrude Stein in Paris and T.S. Eliot in England and Pound first in Paris and then in Rapallo, but back home you had writers such as William Carlos Williams, who was trying to forge a new American idiom.

DC. Who of course was in Paris himself during the twenties.

ELS. Indeed. And then you had Wallace Stevens, who is an extremely original and inventive poet, with a strong Dada element, which I think is not always pointed out.

DC. The Dada element isn't present formally, would you say?

ELS. Well, Stevens was influenced by Duchamp, whom he knew in the twenties.

DC. Certainly in his imagery, indeed even in his concepts, there is a Dadaist streak. But in his actual prosody he is classical, I would say.

ELS. Well, if you are talking about the actual meters and the way it's put together, that's true. But in fact the way the images are put together is not only continental but actually pictorial. The images are collaged together in Stevens, and also in Hart Crane of a slightly later generation. Crane was ambitious to recapitulate most modern styles for the use of Americans, and for instance at one moment he is an imitator of Mallarmé and at another moment he is trying to write the great American epic, *The Bridge*.

DC. Dos Passos was trying to do the same thing with his trilogy.

ELS. But none of this seems to relate to what was going on in art. And the same thing is true in England. You have an experimental literature, but without an equivalent experimental art. In France, on the other hand, exactly the opposite is the case. You have a Surrealist literature which goes absolutely hand in hand with Surrealist painting. You have an enormous number of distinguished Surrealist poets. Paul Eluard is one we haven't mentioned yet. Breton himself was a good poet.

DC. Jacques Prévert.

ELS. Prévert was an extremely brilliant poet, I think, of that period. And there are plenty of others of slightly lesser stature. For example, René Crevel.

DC. And Robert Desnos.

ELS. Desnos is another one. Desnos really came into his own during the war. But at any rate there are writers

enough to spare. I think that what happens in France, what makes Paris unique, is that you have this unified milieu. It had looked for a moment as if such a milieu could exist in England, with Wyndham Lewis, who was a poet-painter, or indeed in Milan, with Marinetti and his painter associates, but the only place that it really worked was in Paris, and I think that's one of the things which gave Paris its unique prestige. Here, on the other hand, what you get, and it's something which writers are still struggling with in English, is a split in the tradition, which is very awkward. In French literature it's still possible today to assume that words and images—painted images, sculptured images—have gone on marching hand in hand, whereas in the Anglo-Saxon countries we glare at each other across this great divide, saying, "What happened? Why didn't we get together?" The getting-together has been more successful in America in the post-War years than it has been in England because you had a strong effort by the so-called New York school—notably Ashbery and Frank O'Hara—to get together with the Abstract Expressionist painters. But undoubtedly there *has* been a split in the tradition, and the thirties were the period when culture ceased to be unified, when it ceased to be possible to refer back and forth between the various arts. Music, which we've just discussed, is another case in point where there are disturbing hiatuses. And when the arts do come together it is usually under the pressure of external events. The great example, of course, is Germany. And there artists and writers were forced to stand together because of the menace of politics. Even so, I don't think that their

standing-together was always as successful as is now made out. The Brecht-Weill opera *Mahagonny*, which is their most ambitious collaboration, is structurally a mess.

DC. What, then, would you say *is* the legacy of the Surrealists? Roger Shattuck has said that the two domains to which Surrealism has made a lasting contribution are love and laughter.

ELS. I'd like to add another "L", and that's liberty. The thing I find encouraging about Surrealism, speaking personally and speaking as an observer of the human condition, is that they never actually did manage to bring about that political alliance they so longed for. There was something stubbornly independent within themselves which always brought negotiations to a halt. I think that Surrealism preserved the best things in Romanticism. Notably it preserved the feeling for the individual and the individual's power to make himself what he chose, even to destroy himself.

III

The Rise of Abstract Art

DC. It's generally accepted that Kandinsky was the first abstract artist. But on the rationalist assumption that every effect has its cause, what caused Kandinsky?

ELS. It's very difficult to say. I think that abstract art as a phenomenon is fascinating in terms of our century because it is the one contribution our century has made which one can point to as absolutely unique. You may like to argue, for example, that certain cultures have forbidden representation before. Orthodox Judaism is one, and of course Islam is another. But when you look at the art produced by a Jewish culture and by an Arab culture you see that there is still, nevertheless, an irresistible attraction toward figuration. The idea that art should be abstract, that it should be a totally independent force without reference to what was found in the natural world is, I think, something which belongs to us alone. The first abstract pictures were painted, as everybody knows, by Kandinsky in 1909, and Kandinsky was at that time living in Munich, which was the capital of the Jugendstil,

the German version of *art nouveau*. And Kandinsky seems
to have been in part inspired by an artist called Alfred
Kubin, who was also a writer. Kubin was a Symbolist,
very much influenced by Goya, very much influenced
by Redon, and he wrote a novel called *The Other Side*,
which was published in 1909, in which he describes a
series of abstract color visions. And Kandinsky seems
to have been inspired to try to realize these. It's undoub-
tedly true that, in general, Kandinsky's abstraction had
a mystical side. His early writings about art play a good
deal of lip service to people like Madame Blavatsky and
to theosophy and so forth.

DC. Simply looking at the paintings one would have
assumed that the physical sciences, not the occult sci-
ences, had been the dominant influence. In fact, half
of his paintings look to me as if they were almost painterly
reproductions of what one would see through the micro-
scope.

ELS. No, I don't think that's true. I think that the figura-
tive Kandinsky shows two currents of influence. One
of them is from Symbolism in general—that is, the sub-
jects, if you look at them, are knights and ladies and
so on, and they are rendered in a manner which derives
from the Nabis,* and especially from that part of the

* A group of painters founded by members of the Académie Julien
in Paris in 1892. They were converted to Gauguin's use of color
and rhythmic pattern by Paul Séousier. The group included Maurice
Denis, Pierre Bonnard, Edouard Vuillard. Toulouse-Lautrec was
associated with them, as was Maillol before he began to sculpt.
Debussy was also linked with the group.

The name, which derives from a Hebrew word meaning "prophets,"
was coined by the poet Cazalis.

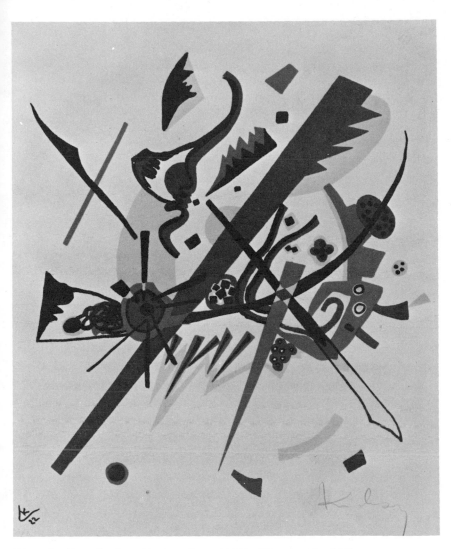

Wassily Kandinsky, *Abstraction,* 1922, lithograph, 10¼ x 8⅞ in. Collection The Museum of Modern Art, New York.

Nabis current which can be traced back to Seurat. That is, they derived from Divisionism.

DC. The pointillistes?

ELS. Yes, among whom the idea was that you put on divided touches of pure color. And in fact the divided touches of pure color become so dominant in certain of Kandinsky's works just previous to 1909 that the subject matter is already taking second place.

DC. One thinks of Kandinsky as such a singular figure, but did he actually work singly? Was there, in other words, any sort of school around him?

ELS. No, Kandinsky was what we would now call a "scene-chief".

DC. But who else was on the scene?

ELS. Well, he started off working under a well-known Symbolist called Franz von Stuck, and then he formed a group which included Kubin, and then later still a group called the Blaue Reiter, in which the other principal figures were Franz Marc and August Macke and Paul Klee.

DC. When precisely was the Blaue Reiter founded?

ELS. In 1911, but you must remember that the Blaue Reiter wasn't committed to abstractionism as such. Abstractionism really seems to have had a Symbolist derivation in general. There is a very strange Lithuanian artist named Ciurlonis who started as a musician and who painted a series of pictures about that time which

are attempts to render musical experience in paint, and while they are not totally abstract, they are so close to abstraction that one can see in them what was to come. In fact, I think that early abstract painting is very largely an attempt to bring painting into line with music as an abstract and rhythmical art.

DC. Without reference to external data?

ELS. Without reference to external data.

DC. This brings up the question of the difference between abstract and abstracted art. All art, in a sense, is abstracted—it's abstracted from figures and shapes which one perceives in the natural world. Can one draw a line, however tenuous?

ELS. I think the line is very difficult to draw. And I think that various artists who are called abstract artists tend to zig-zag across it. But what one can say, is this. In the early years of the present century, artists of all kinds began to draw away from the Naturalism which we've discussed. The impulse was to reduce natural appearances to a pattern, and this pattern could be either further from or nearer to what we would take to be photographic reality. If you look at an early picture by Emile Bernard, for example, or a picture painted by Gauguin, there is a strong element of stylization. Figures are reduced to flat patterns with strong outlines drawn around them. This is what is called by some French critics cloisonnism, after cloisonné enamel.

DC. And called by others the "rage for order", even if it's an order that doesn't correspond to nature.

ELS. Exactly. And what happens then is, with Cubism for example, you have this tendency to break down forms into facets, following Cézanne's prescription that underlying all natural appearances were simple forms such as the cylinder, the cube and the cone. And this produces what people have ignorantly called abstract art. But of course it isn't abstract at all. It still has a reference to nature. When you look at the picture, however much trouble it must take you, you can see the kind of natural object which it began from, whether the natural object is a bottle or a guitar or a person.

DC. Do you feel, then, that the early abstract artists were proceeding from natural models to pure form, to pure pattern?

ELS. No. I think there are two different kinds of abstract artist, one of which is the kind which proceeds to Cubisty scenes, drawing inferences from nature—translating nature, if you like, into an invented dialect—and the other one of which is like Kandinsky in trying to produce something which has no reference to nature, where what exists in the picture is an independent order. And one can see the switch from one method of procedure to another most clearly in the work of the Dutch artist Piet Mondrian, because Mondrian's earlier works move gradually through abstractions from nature to pure abstraction, to the use of the square, to geometry in its simplest forms. And Mondrian was, of course, the most important figure, together with Theo van Doesberg, in the movement which has the claim to have been the earliest to promote abstract art, which is the Dutch movement called De Stijl.

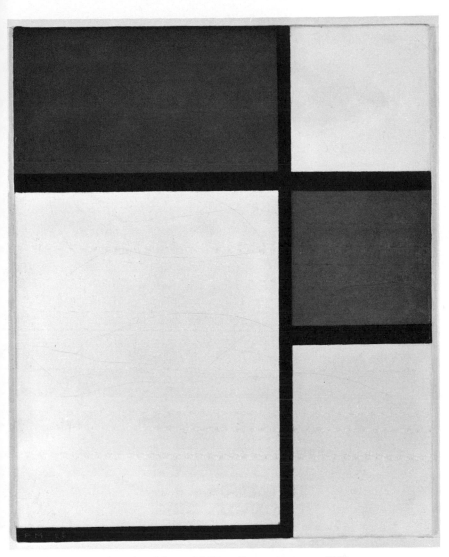

Piet Mondrian, *Composition,* 1925, oil on canvas, 15⅞ x
12⅝ in. Collection The Museum of Modern Art, New York.
Gift of Philip C. Johnson.

DC. Can you define De Stijl for me?

ELS. Well, De Stijl grew up in Holland during the first war, when the Dutch were isolated from Paris by world events. And under the influence of Cubism what Mondrian was looking for was, first of all, a self-sufficient art with no outside reference to objects. He was trying to achieve an art which would have its own harmony, which would make its own rules, deducing these rules from the simplest geometric forms. And there was something else which was very important, which was that De Stijl was very much oriented toward industry, toward technology, and the idea was that the easel picture would only form part of a complex of visual thinking which would also include furniture, architecture and so forth. And the two currents which you have in pure abstract art—having first of all, as we've just done, divided pure abstraction from what one might call deductive abstraction, that is, abstraction deduced from natural forms—are the mystical current, where one meditates on the work of art almost as one meditates on the tantra diagram, and the practical current, where the work of art is merely an object in a world of objects, and has very much the same kind of status as a building, or a chair, or a pattern for linoleum. One of the difficulties, you see, which early abstract art ran into was that it tended to abolish the easel picture. The two principal abstract movements in Europe at this early period, in addition to De Stijl, were Constructivism in Russia and the Bauhaus in Germany.

DC. Before we move on to these two movements, can

you cite examples of the mystical current in abstraction-ism, as opposed to the practical current?

ELS. I think Malevich is a very good example of the mystical current. And Kandinsky. It's a very Russian thing. And it turns up again in a Russian Jewish artist like Rothko.

DC. And of the practical current?

ELS. Well, one simply has to turn to another Russian artist, Lissitzky, who is not primarily a painter, or to the Hungarian Moholy-Nagy, who worked at the Bauhaus and whose whole aim was to direct the creative force of fine art into industrial design.

DC. That seems a good excuse to move East, into Russia and into Constructivism. It's always seemed to me slightly ironic that the one genuinely unique contribution our century has made to the history of art should have come from Russia, which since the twenties has produced the most consistently dull art.

ELS. What happened with Russian art was that the last phase of Russian modernism is represented by Constructivism. Most of the Constructivist artists, such as Rodchenko and Popova and so on, are heavily committed to the Revolution politically and are doing their best to help the Revolution along—making revolutionary festivals, as Jacques-Louis David did under the French Revolution, designing agit-prop trains, trains which carried revolutionary propaganda into the vast countryside of Russia, and so forth. And they increasingly found

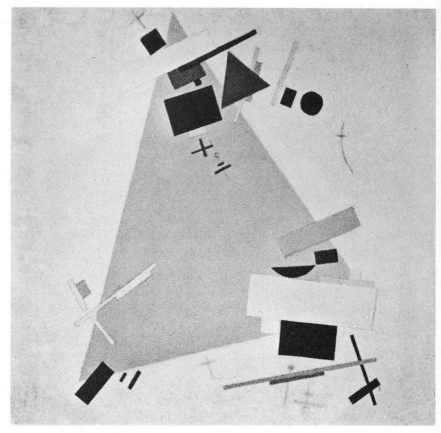

Kasimir Malevich, *Dynamic Suprematism,* 1916, oil on canvas, 31½ x 31½ in. Tretyakov Gallery, Moscow.

that their interests were directed away from the easel picture, which seemed an anachronism in the new society which they were intent on creating. The whole idea was that if art belonged to the people, then the easel picture, which is essentially a private possession, couldn't be tolerated on moral grounds. And when people talk of the Stalinist suppression of artistic experiment in Russia, one of the things I think you have to remember is that many of the leading Russian artists who remained in Russia had already turned away from fine art. They turned toward graphic design, as in Lissitzky's case. They turned toward films, as in Rodchenko's case. They turned toward designing a glider in Tatlin's case.

DC. In a word, they turned toward more public art.

ELS. Not only toward more public art, but to the things which we wouldn't actually classify as art at all, but which would fall under the heading of industrial design. Similarly, when you look at the Bauhaus, which was something which existed in a democratic society, the span of the Bauhaus is almost exactly the span of the Weimar Republic. That is, it starts in 1919 and it's suppressed in 1933, after several moves of location. The Bauhaus had a large group of teachers, including Kandinsky, with very different points of view, but it was dominated on the whole by architects. Its principal was an architect, Walter Gropius, and of course Marcel Breuer was also on the staff, and increasingly the direction of the Bauhaus was away from fine art. Those artists who were most committed to fine art tended either to become less influential or actually to leave, as the mystical Johannes Itten

The Rise of Abstract Art 95

did, who is one of the most important, and one of the least known, of the Bauhaus teachers. And I think there again you got a concern, which was also true of the Constructivists, with the creation of a complete environment suitable for modern man, and a corresponding decrease of emphasis on the fine arts. But all of these movements wanted to create a continuity of forms which would run through architecture, through porcelain, through pictures, sculpture and so forth.

DC. It almost represents a revulsion against preciosity, a sort of lust for the practical.

ELS. Well, there *was* a lust for the practical, but there was also a lust for a kind of uniformity—that all forms encountered by man should be congruous with the kind of new life which he was going to live in technological society. Now that's a very, very strong impulse as far as abstraction is concerned. It's an impulse which continues in the work of the contemporary Swiss artist Max Bill, who is very much an heir of the Bauhaus. And I think one finds a strong element of it in Vasarely, who as you know is against the unique work of art and would rather produce pictures in a series.

DC. It's also a move away from the anthropocentric toward . . .

ELS. Toward the collective, which is exactly what Constructivism was after. Art should be suitable for collective use, and that art which was only for the use of the individual was somehow selfish and socially undesirable.

DC. What happened, apart from the end of the Weimar

Republic, to sap the Bauhaus school of its strength—because it was on the wane, wasn't it, before 1933?

ELS. I think it had long been sapped by the kind of political events which also sapped the Weimar Republic. Also, any institution has a natural term, and an institution as full of high-powered personalities as the Bauhaus naturally tended to be rent by quarrels and schisms of various kinds. It could only grow weaker as it went on. If political events had allowed, it might indeed have been reformed. Such institutions have equally astonishing powers of renewal. But that particular grace wasn't allowed to the Bauhaus as an institution.

DC. Of course a certain credibility is conferred on what one thinks of as the Bauhaus dogma by the fact, for example, that if you go to New York you do not automatically see the work of Marcel Breuer or Max Bill, but you do see the Seagram Building.

ELS. By Mies van der Rohe, who taught at the Bauhaus and was a member of the staff. Well, I think what happened was this. Political events created a diaspora from the Bauhaus, and in fact the Bauhaus's influence was increased rather than diminished, one may argue, by the fact that its staff were scattered to the four winds. Some of them, of course, finished boxed up in Switzerland as Klee did. Klee died in Switzerland. Some of them lived in a kind of solitude. Kandinsky's latter years were spent in rather isolated circumstances. But some of them, like the architects, went to the United States and found opportunities, thanks to American wealth,

which would not have been afforded to them in Europe. Speaking as a European, I find it ironic that the practical Bauhaus style should eventually be harnessed to American luxury. Mies's buildings, like the Seagram Building, are clearly among the most expensive ever built, and they are designed to demonstrate the power and wealth of the corporations for whom they were created.

DC. But they are not really that comfortable to be in, I find. Do you agree?

ELS. The internal spaces of the Seagram Building have certainly been much criticized by later architects, probably rightly, on the grounds that everything has been sacrificed to this unitary form.

DC. You say that Mies sacrificed everything to the unitary form. This may seem a slightly bogus bridge, but I'd like to build it to the unitary canvases of, say, Yves Klein. Can one build a bridge between these two concepts in abstract art?

ELS. Well, Klein is a very difficult case. He is in a way a Dada artist, given to Dada gestures. One of his works was simply to paint a gallery white and put a French Guard Républicain outside the door and invite everybody—and that was the exhibition. This was a typical Dada gesture. And he was very much the center of the group which the French critic Pierre Restany christened the New Realism. I think that one of the curiosities in modern art is that you have elaborate theories which produce simple results, and very often two completely opposite theories can produce in the end the same result.

The unitary canvas can either have come from a Dada philosophy of reducing art to nothing, of being anti-art, or from a Constructivist philosophy of seeking for the simplest form.

DC. One of the things, it seems to me, about the various aesthetic codas that have been promulgated on behalf of abstract art is that they all seem to be saying more or less the same thing, which is: "We are the only modern art."

ELS. I think abstract art has some cause to make that claim. As we said in the beginning, it's the only kind of art for which one can't find a parallel in previous centuries.

DC. What do you find generally striking about the aesthetics behind abstract art?

ELS. What I find striking is this. It's rather like the whole question of the tension between revolutionary art and revolutionary politics as exemplified by Surrealism. You have a tension in abstract art between style and anti-style. If we can go back for a moment to the question of architecture, I think I can illustrate this by an anecdote. On the whole, the great contemporary justification for the "international style"—I am speaking of "international style" as a dead style; I think it died somewhere around 1960—was that it was *functional* architecture. Well, prolonged use of the classic functional buildings has tended to prove that very often function was in fact sacrificed to aesthetic preference. A late example comes to mind from personal experience, from when I was in Havana

in 1967. Just before the fall of Batista a large group of "international style" buildings were built in the Havana suburb of Vedado—a new Hilton hotel, a new apartment block, several other hotels and so forth—and these buildings are, in their way, quite distinguished, and they obviously cost a great deal of money. And they were supposed to be functional for the tropical climate of Havana. Well, some years later their practicality was somewhat open to question because it was based on an extremely elaborate technology which could only be imported. When the air conditioning broke down, those sealed, smooth-skinned "international style" buildings were intolerable to live in. In fact a more practical kind of architecture which instead of trying to combat the climate—as I think those buildings do, in the name of a preconceived stylistic idea—had accepted the climate and had tried to build in terms of what the weather was going to be like all year round. All that elaborate air conditioning machinery, all those ventilators, all those lifts—the whole apparatus was something imposed by the pre-selected style of the building. And a building in a different style would arguably have been easier, simpler and cheaper to operate.

DC. Where, if at all, does Frank Lloyd Wright fit into this?

ELS. Frank Lloyd Wright is the great outsider. He starts off as the exponent of the prairie house. I think he was always a Romantic architect, in a sense that the "international style" architects weren't. If you look at various famous buildings by Frank Lloyd Wright, like the hotel in Tokyo which failed to fall down in the earthquake,

they're built in a style which is quite unlike anybody else's.

DC. His buildings, unlike those of Mies, do seem to conduct a dialogue with the environment in which they are situated, which isn't true of something like the Seagram Building or of what one thinks of as the great abstract sculptures. But let's move from looking at buildings to looking at sculptures. A lot of sculptors after the First World War were certainly influenced by abstractionism. The one that comes to mind, because he's a personal favorite, is Brancusi.

ELS. Brancusi is an example of abstracting from nature. Brancusi was always seeking the ultimate form, but a form which could always be referred back.

DC. To its prototype?

ELS. To a prototype, yes. The seal is still a seal. The fish is still a fish.

DC. And the bird?

ELS. The bird at least has the motion of a bird, even if it resembles a bird in no other way. One of the things we must remember, which is never said, about Brancusi which I find fascinating is that he was a very skillful caricaturist. *Mademoiselle Pogany*, which exists in several versions, that twenties girl in a cloth hat, is among other things a wicked caricature of twenties chic. The sculpture *The Princess* is another example of that kind of caricaturing skill. I think that Brancusi had a unique gift for divining what the lowest common denominator or form was that

was still going to be recognizable. Henry Moore accuses him, as perhaps you know, of being too chic to be a great sculptor, but what he dislikes is the luxuriousness of Brancusi's surfaces, the fact that you have this marvelous hand polish.

DC. You can comb your hair in them.

ELS. And one of the difficulties—I don't know whether you know this—about Brancusi, and one of the reasons why there have been so very few Brancusi loan exhibitions, is that all except the wooden sculptures, which are rough-finished, are tremendously vulnerable to damage. And once you've chipped them, half the magic is gone. Therefore owners are quite rightly very reluctant to lend either the marble sculptures, which are brittle, or the metal ones, which are easily scratched and you could never restore that magical polish again.

DC. Of course that's precisely the sort of point one would expect Henry Moore to seize upon, since most of his own sculptures are designed to be exposed to the elements.

ELS. Yes, precisely. Brancusi is an indoor sculptor. His are works for the inner shrine, while Moore's are works for the temple grounds, so to speak.

DC. What about Naum Gabo?

ELS. Gabo is a much more truly abstract sculptor. He and his brother, Antoine Pevsner, are the children of Constructivism. He is a much more truly abstract sculptor than either Brancusi or Moore, even though all are

ignorantly called abstract artists. I think that what one gets with Gabo, too, is a willingness to experiment with new materials. Gabo was the first person to make really consistent use of perspex. He is a very important figure in many respects. One can point to the fact that he invented kinetic art, at least art powered by a motor, as early as 1920, with a sculpture which is simply a vibrating rod. One can point to the fact that he is, historically speaking, the link between Russian Constructivism and the most important group of abstract artists in Paris in the between-the-wars period, which is the "Abstraction Creation" group which was founded in 1931, and this group in turn forms the licensed opposition to Surrealism. But Surrealism in fact meets increasing resistance during the thirties from artists who no longer accept its premises.

DC. And it was already meeting a great deal of resistance from the public, but so too was abstract art. Indeed, for all the *scandales* created by the Cubists and the Surrealists, I'd say it was the abstract artists who did more to alienate mass public opinion from modern art than anyone else.

ELS. I'm sure this is true, because abstract art cuts across what I consider to be the human impulse, which is to describe, to compare.

DC. And one still wants a painting to be a mirror, just a little bit.

ELS. Well, you see, how do you describe a Mondrian so as to make it absolutely plain to somebody who has never seen one what it should look like? You can only

do it by the most literal process of inventorying areas and colors: you have a black square, or you have a white square so large which is bounded by a black line which is juxtaposed with a red square and so on. Even so, the effect is totally confusing. I have always felt, perhaps because I am a writer and not an artist, that one of our impulses when we are confronted with something strange is to verbalize about it. We teach ourselves by talking. We talk nonsense until we talk sense.

DC. This is a crucial point, for in talking about the difficulties of *describing* abstract art you are really talking about the difficulties of *criticizing* abstract art, because our words refer to things, to images, and we are talking about paintings and sculptures that don't represent things.

ELS. As against that, it occurs to me that one could, of course, put the case of music. It's always been accepted that music is fundamentally abstract. It's true that in the nineteenth century there was the birth of program music, or at least program music came to dominate then.

DC. But there's one key difference, though. At the very simplest level, you can hum a bit of music.

ELS. You can hum it, and you can also write down, thanks to musical notation, exactly how you do it.

DC. But you can't hum a painting to someone.

ELS. You can't hum a painting, no. And I think that the public finds it very difficult to form a bond of empathy with a purely abstract work.

DC. So do the critics. This is my point. The whole history of criticism of abstract art is studded with land mines.

ELS. The criticism of abstract art certainly does set the critic formidable problems, speaking from experience. In my case, for example, we in England tend to have very short spaces and also very large publics.

DC. What do you mean by "short spaces"?

ELS. Well, I will get perhaps 800 words in a national newspaper to describe four exhibitions. If all four of those exhibitions are of purely abstract art then God help me, because I have to explain those exhibitions, I have to give some idea of them, because I think that the critic who simply says, "This is good and this is bad" is shirking his duty.

DC. So you become the last of the big metaphor-spenders to tide you over.

ELS. And that goes entirely contrary to the artist's intention, you see. The artist very often wants to prevent me or any other spectator from being able to talk about his work in metaphorical terms.

DC. So how do you get around this? Or how can anyone get around it?

ELS. Well, it's a little easier with abstract art which has either a mystical cast or a kind of optical cast. If we take the case of Op art, so-called, with a work of a strong kinetic pull you can at least tell what it does to you. You could say it makes me feel seasick. You could say it makes me feel giddy. You could say it affects my sense

of balance. You could say it hurts to look at it. There is at least a choice of reactions.

DC. As, for example, when faced with one of Bridget Riley's works.

ELS. Yes, exactly. I've always thought that Bridget's works were in some respects the equivalent of the gold watch which the old-fashioned hypnotist swings in front of the victim. They are a kind of method of throwing the mind out of gear, so that you begin to free-wheel, you begin to meditate in a certain way. And you can also argue that with a kinetic work you can only report on what it does to you personally, because its effects will be different for everyone else since everyone's physiology is a bit different.

DC. Well, I don't know whether you will agree with this, but I've always felt that the chief duty of criticism, like it or not, is evaluation—not description, not evangelism, although these are component parts of it. And you must admit that on the bottom line of the calculation one has to come up with either "This is good" or "This is bad", or at least "This is better or worse than . . ." How, with non-figurative forms, does one reach this assessment?

ELS. It's a terrible problem. I was going to say that abstract works with a certain mystical cast could also be dealt with by describing the course of meditation you embarked upon after seeing them. Which is, I suppose, a get-out.

DC. And a totally subjective one.

ELS. But, as you know, there's this curious conflict of terms. Abstract artists frequently describe their work as "concrete", meaning that it is not a description of something else, but something *sui generis*, something which exists in its own right. Well, faced with that kind of concreteness, how do you find an equally concrete method of criticism? It is at least arguable that you can't do it at all, that in order to criticize the picture you would have to paint an imitation of it.

DC. But equally you can say that if a work of art, a work of literature, a work of anything is not susceptible to comparative standards of evaluation, this does not mean that all works of the genre, even if they are *sui generis*, are equally valuable, but equally worthless.

ELS. I think the only way out of the critical dilemma can be summed up in the following line of argument. A truly abstract work is not a paraphrase of another object, or set of objects, or gathering of objects, in the sense that a landscape or a portrait or a still life is a paraphrase from three dimensions into two if it's a painting, from unedited reality into some kind of stylistic editing. A truly abstract work, whether sculpture or painting, is simply another object added to the sum total of objects in the universe. That is, if there were 999 billion objects there before, or present in your consciousness, that number is now plus one. So I think the only way in which you can criticize is by saying, "What difference has this addition made?" You can say that it is fundamentally so boring that it has made no difference at all, in which case it is a bad work of art, or you can say that

this particular conjunction of forms has made me look at other forms, not necessarily abstracted, in a new way and therefore has added something to my sensibility.

DC. This is still a reactionary standard. In other words, it's a standard based on your reaction. You're saying that there is no possibility that there is, as it were, a vertical continuum running from "Good" to "Bad" within which one can place works of art.

ELS. I am quite sure that there isn't. And in fact I have painful recent experience to go by on this. As you know, I sit on the Advisory Committee of the Serpentine Gallery, which is run by the Arts Council of Great Britain, and the brief of this gallery is to show the work of artists resident in Britain under the age of 35 who have not received any extensive showing in a London gallery before. This opens up an extremely wide field to us, and we are forced to work without preconceptions of style. The gallery, being a public gallery, is not there to promote any one view of art. Since we are acting on the public's behalf and acting with public money, we have to try to give the public a balanced view of what is going on. Well, to my fascination, but also to my dismay, by far the largest number of submissions—I won't say by far the largest number of acceptances, because that's not true—are abstract art of the kind which we have been chiefly discussing during this conversation. That is, it's geometric "hard-edge" abstraction with no reference to outside reality. And it seems quite plain that the general run of young artists in Britain still think of this kind of art as being the fundamental thing of

modernism. It takes a pretty adventurous artist, or a pretty rebellious one, to depart from that norm. Take, for example, the fact that we have had 400 submissions for the next season: I should think perhaps 150 to 200 of those submissions fall into the category which I have been trying to define. Now I find that I can produce a reaction I am fairly sure of to the other 200, which may be pop, which may be environmental, which may be experiments of almost any kind, or may indeed be figurative art of a fairly traditional kind, but actually to establish an order of merit among those 200 contenders who are abstract seems to me a desperately difficult thing. I am never sure of my own judgment. I think one of the things one looks for in the submissions, and in a way it's a very paradoxical standard, is *consistency*. If one finds that an artist has developed an abstract vocabulary, a vocabulary of forms which is both varied enough not to bore you in example after example—so that one doesn't say, "Oh, not again!" or "I've seen that picture before, haven't I?"—and if at the same time the vocabulary is consistent within itself, then one tends to say that that is better than X's submission or Y's submission, because X's submission looks as if it was painted by three different artists, and Y's looks as if it's all the same picture.

DC. So you're saying that each abstract artist you are confronted with must establish his own standards, and then be judged by the degree to which he meets those standards?

ELS. Well, that's logical if one accepts the premise which I have been putting forward, that each picture is a self-

sufficient universe. It's not really an object added to a world of objects, but it's a small universe dropped into a larger universe, which builds up a wall against the larger universe which surrounds it, which protects itself, which puts up defenses. No wonder the public finds it difficult if it is always being asked to break those defenses down to get at the picture. I think the other comparison which is very useful with abstract art is a semantic comparison. If one can think of the forms used by the abstract artist as a vocabulary, like a language, like Arabic or Spanish or Italian or English, then one expects those forms to be joined together in a fairly convincing way, just as one expects a sentence to be joined together in a fairly convincing way, and one expects the sentences to make a paragraph and so on. So, where the form is not unitary—which is another trap; that is, where you sometimes just have a canvas painted a color, which is an accepted form of art nowadays—but where you have many forms on the same canvas, you can expect them to rhyme and chime and echo with one another, rather as music does, and also to form logical sequences, just as language does.

DC. And without too many adjectives.

ELS. And without too many adjectives, and with economy, and with concision. And the forms must fit together with the kind of snap which you get in a poem which rhymes, perhaps, and that kind of thing. So one at least has a metaphoric system for dealing with abstract art which can be extended to several different kinds of abstract painting.

DC. But, as you said earlier, abstract art in a sense is a rejection of metaphor. So this brings us full circle back to the problem of criticizing art in terms that it rejects and indeed would supplant.

ELS. Well, it seems to me that abstract art in general has been rich in theory and poor in criticism. That is, the theories which people put forward as a basis for their activity are often very interesting, but I think one must be careful to draw a line between a theoretical justification and a *post hoc* criticism of the object when it is presented to you.

DC. Otherwise you get into the intentional fallacy.

ELS. Yes, and I think the other thing which the critic inevitably does—and I think quite rightly too, although some people would contest this very much—is that if he cannot think in terms of the material world then he has to think in terms of other art. That is, when a work by a young artist is presented to you at the Serpentine Gallery, you have to say not "Does it give me as much satisfaction as a Mondrian?" but "How much satisfaction does it give me in comparison to a Mondrian?" In other words, the more abstract art there is, the easier it is going to become to establish standards for judging it, because one will be able to establish standards which involve weighing one work of art against another.

DC. Can we become a little less abstract ourselves now, and go back to discussing specific artists. We have already seen the devastating effect World War I had on the development of other movements in art. What effect did

World War II have on the development of abstract art? ELS. As far as Bauhaus-derived abstraction is concerned, very little. Surprisingly enough. A number of artists had already established their manners, and they existed all over the world. They were sometimes emigrés like Joseph Albers, who worked in the Bauhaus and went to America. They were sometimes natives of the countries in which they worked, like Ben Nicholson. But abstract art had established a sufficient continuity to survive the Second World War almost intact. While there may well be a falling-off of activity in general, and while in certain specialized realms such as England, where there was a strong upsurge of Romantic figurative painting, it may seem that the current has turned against abstraction during the five years from 1940 to 1945, in general one can say that there is a broad continuous stream of development in abstract painting from at least 1919 to the present day.

DC. One thinks of the emergence of hard-edge abstractionism as being a post-War phenomenon.

ELS. Oh, it was never that. Mondrian is hard-edge abstraction. I think what you mean, if I can turn the question around a little, is that there is a kind of abstraction, hard-edge it's true, which seems very characteristic of the post-War period, and that is the kind of abstraction which is hostile to the idea of the closed form provided by the picture surface—the continuous stripes of a Kenneth Noland, the continuous patterns of a Frank Stella, the kind of abstract art which rejects composition. First of all you reject natural form, and then finally you reject

the kind of composition which was originally based upon natural forms. I think that *is* a very important point, and it's something which has happened to post-War abstraction. You can look at it this way, I think. Even when recognizable forms disappeared, or recognizable forms were abolished, the way in which the new abstract forms were arranged in the space available were still based upon what had happened before in painting. That is, you felt a shock of recognition, not as to representation, but as to balance of color and harmony and all the rest of it. And in that sense abstract painting of the thirties still looks back as far as Cézanne in the balance of forms, colors, harmonies, textures. And all these paintings, the Cézannes and the abstract paintings, are based on the human scale. And so is the sculpture. So that when you look at the shapes, they tend to fall into the traditional units which have been recognized ever since the Renaissance: the palm, the forearm, the spread of the arms and so forth. Well, after the war I think there was a desire to get away from that, and it took several forms. First of all you had the kind of composition which was either so balanced and so banal that you couldn't think of it as a composition at all. Hence the great passion for the target shape, the concentric rings of color which one finds in a great deal of post-War abstraction, and also the fascination with the continuous stripe, where the picture might be longer or shorter, perhaps, without necessarily altering it in any way. It is just an excerpt from continuous reality. You are being shown a specimen. It's like a ladle going into a soup pot—you dip out some soup and say, "Here's what it tastes like."

DC. And you've got to imagine the rest of the soup.

ELS. And you've got to imagine the rest of the soup. Exactly. At the same time, you had a development in sculpture which led to the abolition of the pedestal, and also the development of sculpture which became less and less an allusion to the human scale. Sculpture always found it more difficult, oddly enough, to get away from figurative reference, because when you put a sculpture in a space it must inevitably remind you, if it's anything like the same size, of a man or a beast in space. And you got a revolt against that kind of anthropomorphizing view of sculpture, first of all with David Smith, who didn't completely free himself from it, and then later with a British sculptor, Anthony Caro. Caro's sprawling assemblages of girders and mesh are not on the human scale, they have no pedestals. Instead of resisting the space as a Moore does—a Moore sculpture can be thought of as a skin against which space presses, so to speak, which is dimpled in parts and swells out in others in response to the pressure—space flows in between the beams of a Caro, penetrates the sculpture, and creates quite a different sensation when one looks at it.

DC. Well, a Caro is landlord in the space it occupies rather than a tenant.

ELS. Yes, exactly. But it also sprawls outward. This development in Caro's work derives, I think, not only from Smith, to whom it is always attributed, but also from Alexander Calder's mobiles and his stabiles made after the war.

DC. That I can see, but what I can't see is the relevance any longer of the division between abstractionism and figuration in art. Would you agree?

ELS. I think that is a very fundamental question. There has been a prolonged effort on the part of critics since World War II to conduct the debate about modern art in terms of abstraction versus figuration. The sort of question I find both important and puzzling is whether pop art is really figurative art at all. You see, it all derives from pre-digested images. At its nearest to reality it comes from photographs, it comes from designs for packaging, from comic strips, from all sorts of things, but never directly from what used to be called "life". Certainly it doesn't come from the "life" of the life-drawing class, of the old academic painting. And it seems to me that a great deal of pop art is a debate about the vocabulary of representation rather than about representation itself. One is therefore always being forced back on questions of how, rather than why—of how it is done, rather than why it was done. Any subject will do so long as it gives you the springboard for your debate about the grammar of how it's shown. I think that all art nowadays is, in a very broad sense, abstract art. It springs from abstract philosophical premises, and is in grave danger of entirely doing itself out of an audience.

DC. Do you believe, as you seem to indicate, that art which loses its audience must necessarily lose its value?

ELS. I have very mixed feelings on that subject. I suppose one wouldn't say so. But I think the art produced by

the man on the desert island for his own delectation is very doubtfully art at all. I think art must have an audience, that one of the deeply important things about art is the resonance between the creator and the spectator. Some kind of vibration must be set up, and it's that vibration which as a critic I want to put my finger on. But then I'm a socially oriented critic. This whole conversation shows that I am extremely doubtful as to whether absolute values exist in art at all. I think that art has always played a different role depending on the society in which it was created. Ancient Eygptian art is on the whole about death, because they believed in an after-life in a very literal way, and art was used to prop up this belief, to cater to this belief. Art in the seventeenth century was very largely about power, especially at Versailles. In our own day I wouldn't be surprised if it was about hedonistic enjoyment.

DC. Whatever it's about, you think that the further away it gets from the recognizable human referential field, the more in danger it is of disappearing up a cul-de-sac?

ELS. Well, the difficulty is that art has to substitute something else for that direct human contact. That is, if you can't feel for it through empathy—as you can with the little sculpture by Degas I like so much, the *Petite Danseuse de Quatorze Ans*, the young girl in her ballet skirt standing there with her arms wrenched back—then you've got to be able to touch it, to bounce on it, to play with it, to turn it on with a button, something of that kind. I'm not sure that's an adequate substitute. I think we are in a worrying situation.

DC. And what's the answer?

ELS. Well, there never is a simple answer to these questions.

DC. Do you have a complex one?

ELS. I think all one can say at the moment is that the decision to turn art into a separate realm, which is really what I think abstract art is about, was forced upon painters in part by the growth of new methods of representation—I am speaking particularly of photography—but that this separation has created both enormous philosophical and practical difficulties, first for critics and then after the critics for the artists themselves.

IV
Abstract Expressionism

DC. When we think of Abstract Expressionism, we tend to think first of Jackson Pollock. Is there anybody else we ought to think of first?

ELS. Yes, we obviously ought to think of Arshile Gorky, who is the link between American painting in the thirties and American painting in the forties, and also the link between native American preoccupations and the ideas brought in by the European Surrealists when they went into exile.

DC. New York during the war was really a Surrealist refugee camp, wasn't it?

ELS. Indeed, yes. Many important figures betook themselves there to get away from the Nazis. Among them were André Breton, Max Ernst and Peggy Guggenheim, who founded the "Art of This Century" gallery.

DC. How did Gorky's work transmogrify, as it were, into Abstract Expressionism?

ELS. Well, Gorky started like many important American artists of his particular generation. He was, as you know, an immigrant, not American-born, but he started in a characteristic way by recapitulating various European styles. In particular he recapitulated various phases of Picasso's work. When he came into contact with the Surrealists, what he took from them was the idea of biomorphic Surrealism, of forms drawn from the natural world, from plants, from parts of the human body and so on, but put together in a new and original way. I think somebody once described him as the "Ingres of the Unconscious".

DC. It's a good description. How did this lead, though, directly into Abstract Expressionism? Obviously he was the transitional figure, and one thinks, for example, of his theory of the "continuous dynamic".

ELS. And also his preoccupation with the expression of human sexuality through visual art. All his public statements tend to concentrate on this idea, and also on the idea of the picture as a continuing organism, which I think is terribly important to Abstract Expressionism. For him to finish a picture in the traditional sense was to some extent to kill it. That is, Americans were still sufficiently naive, if one can say that without seeming insulting, to take Surrealist ideas and Surrealist doctrine literally. If, for example, you compare what Pollack said about his painting techniques and what Breton said about the way in which one ought to do automatic writing, one sees that there is a very, very strong resemblance.

DC. Well, that First Surrealist Manifesto could almost have been written by Pollock. Or vice versa—what Pollock has said could have been written by Breton.

ELS. I think I can quote a little bit which illustrates that point. What Breton actually instructed you to do, in order to become a Surrealist writer, was to "have someone bring you writing materials after getting settled in a place as favorable as possible, until your mind is concentrating on itself. Put yourself in the most passive or most receptive state you can. Forget about your genius, your talents, and those of everybody else. Tell yourself that literature is the saddest path that leads to everything. Write quickly, without a preconceived subject, fast enough not to remember and not to be tempted to read over what you have written." And Pollock, describing his method of painting, said, "I continue to get further away from the usual painter's tools, such as easel, palette, brushes, etc. I prefer sticks, trowels, knives and dripping fluid paint or heavy impasto with sand, broken glass or other foreign matter added. When I am in the painting, I am not aware of what I am doing. It's only after a sort of get-acquainted period that I see what I have been about. I have no fears about making changes, destroying the image, etc., because the painting has a life of its own. I try to let it come through. It is only when I lose contact with the painting that the result is a mess. Otherwise there is pure harmony and easy give-and-take and the painting comes out well."

DC. There seems to me a fascinating semantic irony in

all this, in that Abstract Expressionism has been known as "action painting", and yet what Pollock is in fact saying is that an action painter is anything but active. He's passive, he's a passive agent of the imagination.

ELS. Yes, he's a passive receptor of unconscious impulses, a mere medium through which these impulses are transmitted to the canvas, physically speaking.

DC. Diego Rivera and the Mexicans were active at this time. Did they have some influence?

ELS. They certainly had some influence on the idea of scale, and many American painters who were old enough to have already been painting in the thirties were originally inspired by Mexican ideas of social connectiveness and so on. And these ideas were reinforced by their own experiences in the W.P.A.-sponsored projects, but I think that one of the things which you do get with the advent of Abstract Expressionism is a withdrawal from social concern. And I find this very significant of American society, speaking as a European.

DC. In a sense the war had solved their social problems, and they were going to solve their aesthetic problems.

ELS. The war did, I think, stifle social debate. It made social debate seem unnecessary. Everybody knew whose side they were on, at least for the time being. And at the same time, thanks to the change in climate, there was a revulsion against the obsessional social concerns of the thirties. People were free to explore the landscape of themselves. I think it was Harold Rosenberg, who is one of the principal theorists of Abstract Expressionism,

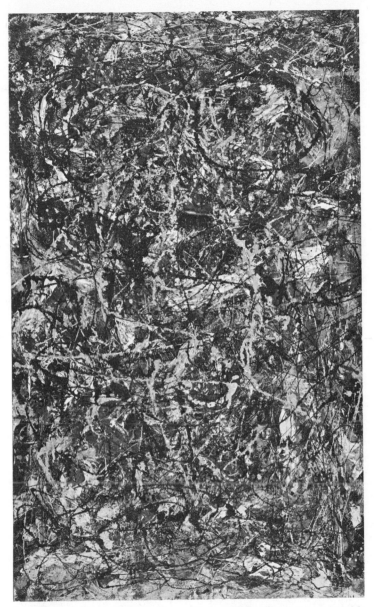

Jackson Pollock, *Full Fathom Five,* 1947, oil on canvas with
nails, tacks, buttons, keys, coins, cigarettes, etc. Collection
The Museum of Modern Art, New York. Gift of
Peggy Guggenheim.

who described Abstract Expressionism as a "conversion phenomenon".

DC. What was the agent of this conversion? What provided the light on the road to Damascus?

ELS. I suspect it was the rather different American attitude toward Freud. We have said in a previous conversation that Freud was already very important to the Surrealist movement as a whole. But Freud—and Freudianism—was, I suspect, a very much more general topic of conversation in the America of the forties than it had ever been in Europe. Americans were able to accept the idea of psychoanalysis much more freely, and the Abstract Expressionist painter was engaged, in American terms, in a perfectly recognizable act of self-analysis.

DC. What part did Hans Hofmann play in all this?

ELS. I think a double role. First of all, his particular technical development toward free abstraction was influential. Also, he was influential as a teacher, as a senior artist who was able to pass on information and instruction to other artists.

DC. The Gustave Moreau of his time.

ELS. Yes. Very, very many important painters had contact with him and were influenced by him.

DC. What about Robert Motherwell? He seems to have been a galvanic influence, as far as one can determine.

ELS. Well, Motherwell is a slightly younger man than the others we have been talking about. He was an intel-

lectual in a sense that the others weren't. And Motherwell was also interested in Dada as well as Surrealism, and I think his academically-oriented researches into the history of modernism did supply a certain amount of theoretical support for other painters who wouldn't have been capable of making such researches themselves.

DC. How did this research affect the other painters?

ELS. I think it gave a sort of historical validity to what they were doing. It provided that very necessary academic basis, even though they were very anti-academic artists. Respectability is what he supplied.

DC. But that's a *post hoc* thing. Did his research in any way affect their actual painting?

ELS. I very much doubt it. I think that what they did was to take Surrealism *au pied de la lettre* in a way which the original Surrealists hadn't been able to. One of the things which I think is extremely significant about at least one wing of Abstract Expressionist painting is its resemblance to writing.

DC. In what way?

ELS. Well, as you know, the original Surrealist prescriptions concerned what you did when you wrote, not what you did when you painted. And I think that someone like Pollock, or even Franz Kline, wrote on canvas—not visible words, but the whole idea of calligraphy, of the looping, intelocking, turning line, was fundamental to their art. You *could* argue in the case of Kline that the resemblance to Chinese ideograms is illusory. The claim

is usually made that the whites of Kline's characteristic black-and-white paintings are as important as the blacks, and that you mustn't think of the blacks as strokes made on a field.

DC. Don't fire until you see the whites of his canvases.

ELS. That's right. And it's also said that Kline's real source of inspiration was not Oriental calligraphy, but the building and demolition business in New York—that the buildings going up and down, the scaffolding, the steel girders around which the buildings were built were the things which inspired him. All the same, I think you've got to say that in a fully-developed Pollock, whether there is a figurative residue or not, what you've really got is a process of doodling. And in many other artists, such as Adolph Gottlieb, you have a concern with the ideogram. And if you look westward out of New York, to Mark Tobey, who as you know is not a New York artist but a Seattle artist, there you have a definite and provable Oriental influence. Tobey traveled to the East, studied Japanese calligraphy and actually spoke of one phase of his painting as being "white writing".

DC. Would you consider Tobey an Abstract Expressionist? He doesn't really seem to fit in with the others.

ELS. No. He's a related artist, but he's not part of the movement. The movement was specifically a New York movement, and he's not a New York painter, he doesn't spring from the New York milieu. But he is sufficiently a cousin of that kind of painting certainly to be treated

in the same discussion. I think the thing which most marks Tobey off from the New York painters is that he has a very different sense of scale, that he tends to paint little pictures while they tend to paint big ones.

DC. Speaking of those big pictures, and your characterization of Pollock's paintings as a form of doodling, I am reminded of a recent interview with people in the street talking about the survival of the Whitechapel Gallery here in London. They asked a lady what she thought of the avant-garde works and she said, "I like them as long as you don't call it art." Now, is it art?

ELS. I think there *was* an anti-art element in Pollock and in the Abstract Expressionists, a desire to crack the accepted formats of art. And I think one of the other things you've got to say about Pollock in particular was there was this enormous physicality. If he was writing, he wasn't writing with the hand, or the hand and arm, he was writing with the whole body. As you know, he tended to spread the surface to be painted out on the floor and to move over and around it, dripping paint from tins, smearing with his hands and so forth.

DC. He was also unique in that he painted first and then trimmed the canvas to fit the painting, rather than trimming the painting to fit the canvas.

ELS. Yes, and I think this says something about the Abstract Expressionists' sense of space, which is very important. First of all, there was a definite attack on the until-then accepted idea of composition. The works were, in that sense, not art because they were "de-

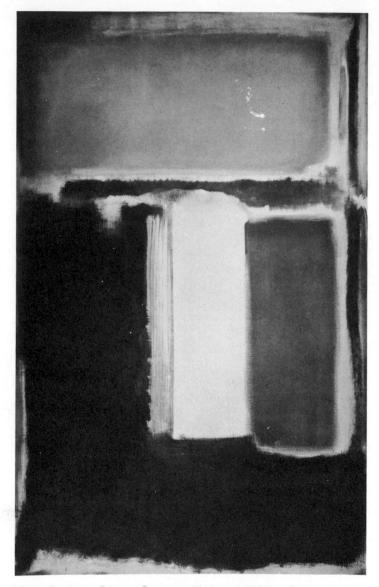

Mark Rothko, *Plum, Orange, Yellow,* 1947, oil on canvas, 68 x 42 in. Estate of Mark Rothko, courtesy Marlborough Gallery, New York.

composed". You had a nucleus which spread out toward the edges of the canvas without quite reaching those edges. That is, the center was strong and the edges were weak. And there was no feeling, which you get in traditional Old Master painting and also in hard-edge abstract painting of the thirties, that the forms were propped and braced against the edges of the canvas. This is why in Abstract Expressionism you get what's called the unitary image. So that there *is* a certain liberty of trimming in Pollock's canvases: he made the decision about how to trim them afterwards.

DC. But you don't find this so much in an artist like, say, de Kooning.

ELS. No, but de Kooning is a much more European artist. It's arguable that de Kooning, who is the most figurative of the Abstract Expressionists, would be better described as a straightforward Expressionist who happened to have got caught up by bonds of sympahty with the Abstract Expressionist movement in America. There's also a very strong link, it seems to me, between de Kooning, who is Dutch by origin, and the Dutch and Belgian artists of the Cobra group, such as Appel.

DC. You've said that Pollock, Kline and de Kooning belong to one wing of Abstract Expressionism. Presumably the other wing is that which you find in artists like Mark Rothko?

ELS. Yes, indeed. But here again you have the idea of the central image which floats on the ground. One thing we haven't mentioned, and I think it's terribly important,

especially from any psychological or psychoanalytic point of view, is the Abstract Expressionists' sense of space. In the case of Pollock, and indeed in the case of Rothko, people talk of this idea of the "shallow space" as the thing they have in common. That is, Pollock's lines of paint and Rothko's softly brushed forms, his irregular squares, float against a space. They are not pinned down flat to the canvas in a way that Cézanne's forms are. There is the suggestion of something against which they float. The thing which really seems to me very significant about this space is that it's conventionally called shallow space, as I've said, and yet it's an undefined space. It has no perspective. It is the space which exists within the mind, one might almost say. And when I think of Rothko's work, I am most struck by its mysticism, by the fact that these are things or objects upon which one meditates, which concentrate the mind, or which help you concentrate the mind on meditation without necessarily dictating what that meditation is to be about. That is, it provides a focus and also an emotional coloring, but nothing more specific. And what I think that the Abstract Expressionist painters in general were trying to do—and Rothko and Pollock are the most striking examples—was to suggest that one could plunge into that realm of the mind where one believes that space exists, but that space is undefined in any logical way. The science-fiction writer J.G. Ballard has coined the phrase "inner space" in recent years, and I really think that is what the best Abstract Expressionist painting is about.

DC. Which evokes the key figure of Barnett Newman. The importance of his work seems to have increased,

with several major exhibitions around the world since his death in 1970. Harold Rosenberg sums up his contribution well. Here is what he says: "Newman is said to have basically influenced the art of the sixties through pioneering in one-color painting, in paintings of mammoth size, in his manner of dividing and shaping the canvas. This may be true, but more important to me is that he indicated the exact position of art today, insofar as it is ambitious for greatness. I mean that it must run the risk, apparently unavoidable, of not seeming art at all."

One of the interesting things about this whole movement is that it happened in America first.

ELS. I think it's highly characteristic—and not only of the political situation of the time—that American art should suddenly become a pioneer. It reflects certain things which seem to the European characteristic of American society.

DC. Such as?

ELS. Well, there's a strong lack of social connectiveness. If you compare a large painting by Léger, such as *Les Constructeurs*, with a large painting by Pollock, such as *Blue Poles*, they are at opposite ends of the social spectrum. One is an entirely social statement. It's an attempt to speak for the mass, to speak about things such as the dignity of labor, while the Pollock is an attempt to speak for the sovereignty of the individual will.

DC. You do, however, with things like Motherwell's *Elegy to the Spanish Republic*, get a sort of social connectiveness, if only in the title.

ELS. Yes, if only in the title. If you weren't told it was an elegy to the Spanish Republic, you might quite easily invent a totally different context for yourself. While the Léger I have just mentioned, with all those brawny, slightly tubular workmen on tubular scaffolding, is quite explicit.

DC. But isn't this really just the difference between figuration and non-figuration, rather than the difference between socially committed art and "pure" art?

ELS. No, I think there is a deliberate vagueness. And I think there is an attempt to use that vagueness to represent the flux of the consciousness in Abstract Expressionism. Abstract Expressionist pictures are essentially in a state of becoming. The complaint was made about them at the time—I think Mary McCarthy was one of the wittiest of the complainants—that looking at an Abstract Expressionist painting was a bit like looking at the bull ring after the bullfight was all over. You got the blood and the scuffed-up sand, but none of the action.

DC. The action having gone into the act of painting.

ELS. Yes. You see, it could be argued that the real point of crisis with the Abstract Expressionist work of art was not in seeing the result but in seeing the actual act of painting—and that the painting was a kind of relic, a kind of certificate or guarantee that certain activities had taken place previously which you were not there to witness.

DC. You've said, more or less, that an action painting or a piece of Abstract Expressionism is an ideogram of

the American psyche. Can you expand on that? What do you see in the painting that you also see in the American character?

ELS. Extreme concentration on the individual, desire to plumb the depths of the individual, combined with little organized sense of social responsibility.

DC. But I would have thought that Americans are very socially aware, and especially at that time, with the upsurge of interest in sociology and so forth.

ELS. I think Americans are very concerned with the social sciences. It's part of the American concern with technology. But sociology in America is, as I understand it, a technique.

DC. Applied mind-engineering.

ELS. Exactly. But I think that one of the things which happens in America is that the avant-garde becomes translated into the frontier—that characteristically American idea, where every man is out for himself, every man is pioneering away. A man's own personal integrity, à la Hemingway, is the thing that counts.

DC. To borrow that metaphor, having won the West, how did they win the East? How did they export Abstract Expressionism to Europe?

ELS. It wasn't an absolutely straightforward export. European art after the war was already moving in that direction, even before Europeans became aware of Abstract Expressionism. In fact Abstract Expressionism didn't arrive instantly in Europe, as subsequent styles

have done. It took at least until 1948 before French circles were aware of Abstract Expressionism. Peggy Guggenheim toured her collection of early Pollocks in Europe.

DC. How did it then take root here? Was it grafted on to a movement that was already growing?

ELS. Well, the movement in Europe was called "Art Informel" and it sprang from several different roots. It sprang from a renewed interest, almost an exaggerated interest, in the *matter* of painting—*la belle matière*—textures and that kind of thing. With a painter like Fautrier, for example, you get a re-emphasis of what was considered to be a particularly French characteristic. In a series of paintings called *Otages*, which were inspired by people he had seen being shot by the Germans, there are faces, but the faces are allowed, so to speak, to emerge out of the flux of paint, rather as some of Pollock's images emerge.

DC. Do you think its success in Europe, then, was due to the force of the movement itself, or to the fact that America was, as you've described it, the "boss culture"?

ELS. I think that the climate already existed in Europe, not only with Fautrier but with various dissident Germans like Wols and Hartung. Wols, like Fautrier, was supported by René Drouin, the dealer, and he had been making small drawings with some relationship to Klee, elaborations of unconscious fantasy, calligraphic elaborations, and Drouin invited him to paint instead of making drawings. And when he painted, the results were in some ways very like American Abstract Expressionism. I think

that the climate already existed in Europe, that it was a universal climate, that Surrealism had also prepared the way there. But the confidence, the swagger and the scale, and also the extremism of the American variety, tended to overcome the European one.

DC. This is the first time that had ever happened, isn't it?

ELS. It's the first time it had ever happened, but it's very characteristic of the development of culture as a whole. Just as Europe took its tone from the court of Versailles, because Louis XIV was the most powerful monarch in Europe, so Europe in our day has taken its tone from New York, which is representative of the political and financial supremacy of America.

DC. When this painting got to Europe, would you say it collided with, or subsumed, the figurative impulse?

ELS. I think it collided with the figurative impulse, basically. There was a figurative movement in Europe after the war, which took different forms in different countries. Its most impressive manifestation, to my mind, was the Cobra group which was in Copenhagen, in Amsterdam, in Brussels. The Cobra group was a group of Expressionist painters creating figuration from the imagination. Characteristic artists are Appel, whom I've already mentioned, and Asger Jorn, the Dane. And they were making an attempt to revive the Expressionism of northern Europe which had existed before and just after the First World War, and which had been a particular target of the Nazis. Artists such as Nolde had been particularly

persecuted by the Nazis. Then there was an attempt in Italy, parallel with the realistic films which were being made there—Rossellini films like *Città Aperta* and so on—to revive a kind of realism on doctrinaire Marxist grounds. The greatest survivor of this particular impulse I think is Renata Guttuso. In France figuration was connected with existentialist ideas and with what was then called "Miserabilism", an attempt to reflect the miserable condition to which Europe had been reduced. The most distinguished Miserabilist artist, so distinguished that we forget his origins, is undoubtedly Giacometti. Those thin figures weren't merely a case of trying to render a particular sensibility about space. I think his work was—and certainly it was taken at the time as—a literal attempt to render how starved everybody felt. And there were other popularizers of this manner who have now, although they do financially perhaps as well as they did, fallen out of favor with intellectuals, such as Bernard Buffet.

DC. I suppose you could say that action painting is really a supreme example of existentialist creativity. Indeed, Pollock himself seemed to be the prototypal existentialist man, even to the point of dying in a car crash.

ELS. Yes, except that the existentialists did have severe doubts about the fact that Pollock was abstract, because they themselves, as well as being the children of German philosophy such as Heidegger's, were the children of Marxism. The connection between existentialism and Marxism has never been sufficiently stressed. It's very visible in the career of Jean-Paul Sartre, for example.

And one saw in England, which remained resistant to Abstract Expressionism for much longer than almost any other country, the rise of a realist school which is now considered embarrassing to mention, the so-called "kitchen sink" painters.

DC. Whom would you include among the "kitchen sink" painters?

ELS. The leading ones were John Bratby, now an academician, Jack Smith, now very much an abstract painter, and Edward Middleditch, who has remained, I suppose, oriented in much the same way as he always was.

DC. Do you think this school grew up in direct reaction to Abstract Expressionism?

ELS. I think in some respects it did. It was very much promoted by the English Marxist critic John Berger, who was the most powerful voice in the arts in England at that time. Berger certainly regarded it as an answer to what he called "abstraction", but I think by "abstraction" he meant the fashionable abstraction of the Danish, "free" abstraction.

DC. Of course there was also the work of the Austrian critic Ernst Fischer.

ELS. Yes, there was a definite critical attempt in Europe to set up some kind of opposition to Abstract Expressionism, an attempt much more on the part of the critics than of the painters. The most interesting opposition phenomenon in England was not the "kitchen sink"

school, but the kind of very, very painterly figuration you get in two artists who are extremely similar to one another, Frank Auerbach and Leon Kossoff, where you have the figurative image built up in great whorls and coils of raw paint straight from the tube, rather in the fashion that an Abstract Expressionist's image is built up.

DC. Would you agree that at least in part this was a guerilla movement against cultural imperialism? Europeans didn't want to be colonized by a former colony.

ELS. Certainly in England that was true. I think the French were more sensible about Abstract Expressionism and realized its importance much earlier. It led, of course, to an enormous art boom in Paris eventually, in the late forties and early fifties, an art boom connected with the idea of "Art Informel", as it was called, "art without form". Or as the critic Michael Tapiès christened it rather more cleverly, *un art autre*—"another art", an art other than the one we know. I don't think that in the end it lived up to Tapiès's claims to be so totally and radically different from what had gone before. The element of painterliness always survived in Europe. I think a key figure, though not a great artist, is the Frenchman Georges Mathieu, who is both the most calligraphic, the most like Pollock of European artists, and at the same time was the great promoter of the reputation of the Abstract Expressionists in Europe. But if you compare a large Mathieu to a large Pollock, you become immediately aware of how much less complex the Mathieu is both psychologically and even technically. While the Pollock has this image which whirls and rotates

in this indefinable but nevertheless pleasant shallow space, the Mathieu is a series of calligraphic marks on a surface which remains absolutely even. I always feel when I look at a Mathieu that I can easily separate the ground from what is painted on the ground, while I always feel that with a Pollock this particular separation is impossible, and that's part of the fascination.

DC. So Abstract Expressionism was never really at home in Europe? It was artificially adapted, but it never took root the way it did in America.

ELS. Well, I don't think it was at all a product of the same social situation or sensibility. The most important, the most original artist in Europe at the period when Abstract Expressionism was triumphing was Jean Dubuffet. And Dubuffet is in many ways very informative, when you look at his *oeuvre* as a whole, as to the differences between the European and the American sensibility. One of the things about Dubuffet is his fascination with doing the elegant, economical thing with the raw means, with means which seem impossibly clumsy. I can think of a series of sculptures made of lumps of coal, for instance. And you also have with Dubuffet an almost exaggerated interest in matter. There's a series of paintings called *Texturologies*, which are investigations of a most devoted kind of what you can get when you make texture the dominant thing in a picture. And you have the exploration by Dubuffet of all sorts of very strange materials, like moths' wings and butterflies' wings, for making images. And this has a preciosity which absolutely isn't present in American Abstract Expressionist painting. This con-

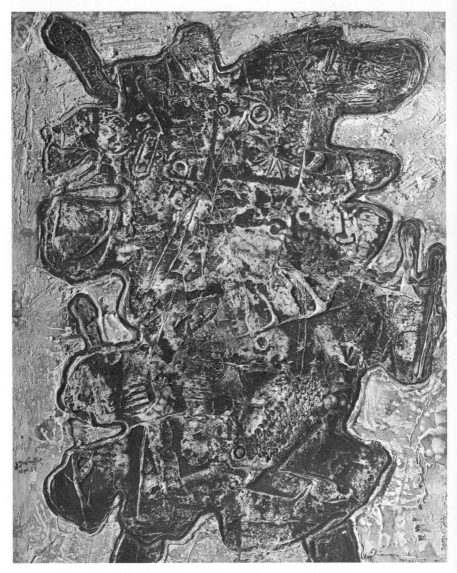

Jean Dubuffet, *Chevalier Vagabond,* 1951, oil on canvas, 22¼ x 27⅜ in. Collection McCrory Corporation, New York— Promised gift to The Museum of Modern Art, courtesy Pace Gallery, New York.

cern with the means, this feeling that the means and the end are the same isn't present at all in America. It's a purely European thing. And it's related in Dubuffet's case to the writings of a poet like Francis Ponge. Ponge gets his effects by devoted description, whereas the American equivalents of Abstract Expressionism are the Beats.

DC. This seems a good point at which to bring up the relationship between Abstract Expressionism and other so-called avant-garde art forms and artists who were emerging at the same time. For example, I would have said that there's an influence, or at least a point of tangence, between the Abstract Expressionists and, say, someone like Robert Duncan or John Ashbery in poetry.

ELS. Well, I think you've named one who is relevant and one who is not.

DC. Which is which?

ELS. I think that Duncan is not relevant, that Duncan is part of that complicated Pound descent, which includes poets such as Robert Creeley and Charles Olson and which is cross-connected in the arts through John Cage eventually with artists such as Jasper Johns, through the association of many of these people at Black Mountain College in North Carolina. I think that Ashbery and his associates, of whom the two most important are Kenneth Koch and the late Frank O'Hara, definitely did set forth to try to produce an equivalent of the painting they admired. The American poetry of the forties, which enjoyed precisely the same vogue in Europe which

Abstract Expressionism did, was on the whole a very neat, structured, traditional, academic poetry. The principal representative of this phase of American writing is Richard Wilbur, but these East Coast academics conquered, in the same way that Abstract Expressionist painters did, in the name of very different values.

DC. I'm interested by your use of the word "vogue". Do you see Abstract Expressionism primarily as a vogue, as a fashion, as a temporary movement without lasting consequences for art?

ELS. No, I don't see it as that. But I also don't see it as the ultimate style of painting. I *do* think that Abstract Expressionism carried the idea not of painting but of paint as far as it could go, and I think it also probably carried the idea of conventional format as far as it could go. I would even perhaps add a third suggestion and say that it carried the idea of fine art as opposed to pop art as far as it would go. It is the last time that one could draw the line between the art of the committed art person and the art created by a popular upsurge of mass taste.

DC. Talking of mass taste, one of the mass reactions to Abstract Expressionism is that anybody can do it. *Can* anybody do it?

ELS. I doubt it very much. You see, there was a second generation of Abstract Expressionist painters, of whom the only distinguished member that I can think of was Helen Frankenthaler, who to some extent reverted to conventional landscape idiom. What I think happened

was that Abstract Expressionism is really a very aristocratic style, with its obsessional concern with the psychology of the individual, and I think collectors reacted to it in that way, making Abstract Expressionist paintings very rapidly among the most expensive in the world. Because Abstract Expressionism was supposed to reflect psychological depths, it became very much the concern of an elite who thought of most people as being incapable of appreciating what *they* appreciated. I think the world of modern art was seldom more cultish and exclusive than when it worshipped at Abstract Expressionist shrines. The thing which I find particularly striking is that Pollock in particular was a splendid example of the difference between what you are told you ought to think and what you do think when you look at the pictures. I wouldn't make this observation about Pollock's canvases where figuration is used, because I think they do reflect a strong sense of anguish very often, but with the abstract canvases you're told that you should think of them almost as an outpouring of blood, as an expenditure of the self, and yet those great late paintings like *Blue Poles* came across to me like a decoration by Tiepolo. They are magnificently joyous, splendid, energetic and, I think, totally without darker spiritual undertones. But that may be my insensitivity as a critic.

DC. What has been the reaction of the collectors? Have the paintings held their market value?

ELS. Oh yes, very much so. One must admit, of course, that high prices at auction have also been made by pop artists such as Andy Warhol, but basically I think that

Abstract Expressionist painting is the individual speaking to the individual and that there is an element of flattery and self-flattery about the response to it.

DC. Indeed even of snobbery.

ELS. Even of snobbery. And of course there is a degree of nationalism also in the response to Abstract Expressionist painting, in a financial sense, in that American collectors are undoubtedly influenced by the fact that this was the point at which American art made the breakthrough, and they want representative specimens of those heroic days when America at last established itself as being something more than a province where the visual arts were concerned.

DC. Obviously one can't say that Abstract Expressionism was a provincial art form, particularly as it masqueraded as the ultimate universal form, but it does seem to me slightly a period form.

ELS. Oh, undoubtedly. One recognizes it as the characteristic expression of a time which has already passed. So much so that one can speak of a typical Abstract Expressionist painting. I find it deeply significant that this enormously free technique, this liberation, as it then seemed, should in fact have had stylistic rules which are readily recognizable to the point where it is possible nowadays to produce an academic imitation of Abstract Expressionist painting, just as it's possible to produce an academic imitation of Impressionist painting. That liberation had its own conventions. And indeed I would say the development away from Abstract Expressionism

has been a loss of innocence, particularly a loss of American innocence.

DC. What are those stylistic rules, those conventions? Not that they can necessarily be codified, but how do you approach the paintings as a critic?

ELS. I know the critic is forced to approach them in terms of personal impact, since they are all about personality anyway. I think that one's judgments of Abstract Expressionism are made in the way that judgments *ought* to be made in a sense: one starts off with what seems to one to offer some approach to absolute merit, such as a good Pollock, and one compares the less good with that and tries to work out why it's less good.

DC. But with someone like Rothko, particularly, the judgment must be so utterly subjective that it therefore becomes so individual that it loses any universal validity.

ELS. Well, it's not the first time that that kind of situation has arisen in art. The same thing might be said of Japanese tea ceremony wares. Europeans always find it very, very hard to decide why a particular tea bowl should be a great tea bowl, while one which looks very like it should be a second-rate tea bowl, but the Japanese seem to have no difficulty. I think that the judgment draws on complex sources of cultural information, too complex to enumerate. In the end, Abstract Expressionism must be regarded as the American imperial style, created at the height of the American Empire.

V
Pop Art

DC. One automatically thinks of pop art as the one quintessentially American movement in the arts. But in fact it began in England, didn't it?

ELS. Well, there's a very paradoxical situation connected with the beginning of pop art. It did begin in England and it began through the English nostalgia, during the years of austerity after the war, for what was seen as the abundance of America. The first pop art work is generally held to be by the English artist Richard Hamilton, and to be the collage *Just What Is It That Makes Today's Home So Different, So Appealing?* which appeared in the "This Is Tomorrow" exhibition at the Whitechapel art gallery in 1956. It's a collage, as I said, and it draws its source material almost entirely from American sources. In those days artists such as Hamilton and Paolozzi were absolutely fascinated by American magazines of all kinds, by American advertisements. They collected copies of *Life*, they collected comic books.

Richard Hamilton, *Interior*, 1964, serigraph, 22¼ x 27⅜ in. Collection The Museum of Modern Art, New York. Gift of Mrs. Joseph M. Edinburg.

DC. The Hamilton collage is very much of the *Better Homes and Gardens* variety, isn't it?

ELS. Well, Hamilton is a finicky, extremely refined, very intellectual artist, and I don't think that his work has anything like the feeling of American pop, or indeed much of the feeling of work by British artists younger than himself. You see, one can say that the emotional roots of pop are in the British nostalgia for a better life, but its intellectual roots are in Dada. We mentioned Motherwell in the conversation which preceded this one: it was Motherwell's book on Dada which was one of the great sources of American pop. The transitional artists between Abstract Expressionism and pop art are usually held to be Jasper Johns and Robert Rauschenberg in America. Well, neither Johns nor Rauschenberg is recognizably pop in the sense that we think of it now. Rauschenberg is a maker of collages and combine paintings, with many different images. These images are drawn from all sorts of sources—sometimes from the fine arts. There's a very famous picture of his which has a reproduction of the Rubens *Venus Looking In A Mirror*.

DC. Rauschenberg could almost be considered a Dadaist back-number in his use of ready-mades and the way he incorporates them in his work.

ELS. But he's also a great user of "free paint", of smeared paint, and in that sense he relates to Abstract Expressionism. And Rauschenberg was also one of the people who were most closely connected with Black Mountain College.

DC. But doesn't Rauschenberg use his paint really as a way of inducting these external objects into the context of his painting?

ELS. Yes, I think he uses the paint as a way of unifying the different images. One of the things, of course, which does make them seem pop is that the images are often meant to be read sequentially, and therefore you get something which alludes to the techniques of the comic strip.

DC. And not just read, but actually listened to. I remember he had a radio in one of his paintings.

ELS. You find almost anything in Rauschenberg's art, from an old radio to a stuffed goat.

DC. In fact he also reminds one of Schwitters in this Hoovering-up of objects.

ELS. Yes indeed, he does. He is one of the pioneer figures in the so-called art of assemblage after the war, and that was definitely directly related to Schwitters and to Dada.

DC. And that was the bridge between Abstract Expressionism and pop?

ELS. Yes, through a renewed interest in Dada. It was as if Abstract Expressionism, which is also late Surrealism, had suddenly decided to go back to its very beginnings. The other thing, of course, which you get—in Johns much more than in Rauschenberg—is the use of the deliberately banal image, the image which is so banal that the artist feels it will carry no charge of meaning.

DC. I remember your saying once that the whole point of Johns's images is their lack of point.

ELS. Exactly, yes. You get the use of the American flag not even seen in perspective. You get the use of these targets which also turn up in abstract painting at about the same time.

DC. You know that they carry an ironic charge, but which way the irony is directed is what's baffling.

ELS. I think Johns wanted to have something which had even less meaning than original abstract design. The American flag could be thought of as an unoriginal abstract design, if you care to put it that way, and that enabled him to play with all sorts of effects of texture, of color-grading and so forth, and to concentrate your attention on those effects without having your attention wander toward something which to him was irrelevant.

DC. We've talked in other conversations about the vibrations between the artist and the person who is viewing the work of art, and it seems to me that Johns has always played on the fact that people are going to bring certain emotional information to these paintings, that they have invested things like the American flag with emotional meaning which is going to significantly affect the way they see his painting.

ELS. That's not the theory which he puts forward himself. He is one of the earliest artists to put forward all those theories about what one might call the grammar of representation—the *how* of the way in which you represent things: whether you show them literally, whether you reduce them from three dimensions to two and so forth. That's the kind of thing which interests him, and it is very largely the subject matter of much American

pop art. And it seems to me that the difference between American pop art and English pop art is that for the Americans the subject matter is often an excuse, while for the English it is the *raison d'être*. You see, two of the leading English pop artists, so-called, are really artists who are interested in reality in an almost Victorian way. I'm thinking of Peter Blake and David Hockney. They are both essentially celebrators of a culture which perhaps had been up until then despised by intellectuals, denigrated by them.

DC. The middle-class, materialistic culture?

ELS. Exactly. Hockney, for example, in his suite of etchings *The Rake's Progress,* made in 1961 I think, takes an affectionate if also satirical view of the United States, which he was then seeing for the first time. His rake's progress is a progress through American culture, a celebration of American culture. And if you take a picture like Peter Blake's *On The Balcony*, which is an early work, where he shows a whole row of children with the things which fascinate *them*—which are mostly, so to speak, pop art things—the title has a double meaning. It's not only that they are on the balcony like the Royal Family at Buckingham Palace, but they are on the balcony in the sense that they are displaying themselves, that they are coming out into the open about their real preferences.

DC. Well, there's a very large element of deliberate showmanship, almost of hucksterism in pop art, wouldn't you say?

ELS. Yes, I think there's certainly an element of deliberate

showmanship in the pop art world. One of the curiosities about pop art, as opposed to the style which preceded it, Abstract Expressionism, is that pop was made by dealers and collectors, whereas Abstract Expressionism on the whole was made by theorists and critics.

DC. What do you mean "made by dealers"?

ELS. Promoted by dealers, taken up by collectors and very generally denounced by the established critics of the early sixties.

DC. But it wasn't like a publisher commissioning a book: having an idea and then asking somebody to write on it.

ELS. No. The pop phenomenon actually brushed aside the art intellectuals, although in England there was a kind of theoretical background which was supplied by the so-called "Independents Group" which met at the Institute of Contemporary Arts in London. This group included Richard Hamilton, the sculptor Eduardo Paolozzi, who is not entirely a pop artist, the two "New Brutalist" architects Alison and Peter Smithson, Rayner Banham, who is an architectural critic and also a critic of the fine arts, and Jasia Reichardt, who is an art critic and maker of exhibitions. So there definitely was an intellectual thrust behind the interest in pop artifacts.

DC. But it came from a curious alliance between artists and their dealers, rather than artists and their apologists.

ELS. Well, dealers found that pop was saleable and they found it was saleable because the customers could actually

recognize it. The whole business of effect and affect took a much more direct route.

DC. And of course pop art took a lot of its images from things that had already been sold rather spectacularly, like Coke bottles and Brillo pads.

ELS. Well, Hamilton said that among other things pop must be glamorous and temporary and appealing and commercial. And I think that pop artists were definitely enamored of the idea of commercial success. For them it had a kind of ironic virute.

DC. Don't you see a certain irony also in the fact that pop art was trying to make permanent the ephemeral?

ELS. I don't think it *was* trying to make permanent the ephemeral.

DC. I'm thinking of a painting of a Coke bottle.

ELS. Well, my impression is that something rather different happened: that it *embraced* ephemerality. I said, when I reviewed the earliest of the English pop art exhibitions, that here were all these images running hard for cover, that they were like the rabbit which dashes out from one bush and bounds toward the next before you can shoot it.

DC. But at the same time the paintings weren't painted to be discarded.

ELS. I am not sure about that in the beginning, I must say. I think that a terrible fate has overcome pop in that it has become fossilized. But I can remember that the idea was, at first, that you had paintings which were

just as temporary, even though they were fine art, as the artifacts of mass culture. And I can also remember Roy Lichtenstein saying in an interview, which was afterwards quoted in the catalogue of the exhibition which the Tate Gallery devoted to him, that he had wanted in the beginning to make pictures which were too awful for anybody to hang.

DC. Do you think he succeeded?

ELS. Clearly he didn't.

DC. What do you think of Lichtenstein?

ELS. He's the Poussin of pop art, the great maker of almost mathematically calculated canvases. The small adjustments he makes in his borrowed comic-strip images are in fact designed just as Poussin's adjustments to reality are designed: to produce a feeling of classical harmony and order. He is also, as American pop artists are, a deadpan ironist about modes of representation. In fact, one sees that much more clearly in him than in anybody else. He did a series of brush-stroke pictures where the Abstract Expressionist brush stroke was deliberately rendered in coarse, comic-strip technique, with the dots and the hard black outlines and so forth.

DC. This is certainly the mode one associates with Lichtenstein. When I think of him, I think of comic strips.

ELS. Yes, but he has used that technique on all sorts of other things. He did a series of pictures which were the backs of canvases.

DC. I remember those. Now, who were the other important American pop artists at this time?

ELS. The most important was obviously Andy Warhol. One could also mention Jim Dine and Robert Indiana and James Rosenquist as being among the leaders.

DC. And Oldenburg?

ELS. And Oldenburg. Oldenburg is particularly interesting because he has had this concern for the three-dimensional which does not naturally occur, I think, in most pop art. Also, he has had this idea that you radically alter an image by transofrming the substances of which it is made. That is, if you made a hamburger out of stuffed canvas shapes, you somehow removed it from one kind of materiality and substituted another. You gave the hamburger a different flavor, so to speak.

DC. How, in your opinion, did Warhol achieve his ascendancy in the pop art world?

ELS. It's a fascinating question. Warhol has been the most skillful exploiter of the media in the whole of the art world that I ever remember. I think that his pronouncements, such as the one about wanting to be a machine, are in flat contradiction to the way in which he's manipulated his public image, which has made him one of the most conspicuous and least mechanized individuals in our society. I think that Warhol really owes his success to a misunderstanding which he himself has cultivated.

DC. Which is?

ELS. The public have gone for the subject matter, the

Claes Oldenburg, *Giant Fag Ends*, 1967, canvas, urethane foam, hydrocal, liquitex on formica and wood, 96 x 96 x 96 in. Collection The Whitney Museum of American Art. Gift of The Friends of The Whitney Museum of American Art.

Jackie Kennedys and the Marilyns and so on, while Warhol himself has not really been at all interested in the subject matter. It has merely been an excuse to allow him to explore his own preoccupations. And I would have thought that his own preoccupations were, in order, boredom and exclusivity.

DC. One certainly associates bordom with his films.

ELS. The earliest films were, I think, explorations of the idea of boredom, of how you got bored, of whether you were bored when things were put in a certain context. You remember the film of the Empire State Building, which went on for hours and hours and hours, and the film of a man sleeping, which also seemed to go on for hours and hours and hours.

DC. It went on for about eight, actually.

ELS. And also Warhol had this theory that if you looked at something long enough without wavering, it would somehow be forced to give up its secrets to you. He made a portrait film of Henry Geldzahler, and I remember Geldzahler saying to me that if somebody merely took a snapshot of you, you could arrange your features to suit the image you wanted to convey, and if somebody painted you, in a traditional sense, they would arrange your features in the sense that they wanted to convey. But the unblinking eye of the unmoving film camera, which just goes on looking and looking and look-ing and looking, must eventually pick up the truth about all your mannerisms and ticks and so forth, and must

in fact be a more penetrating instrument than any less mechanical device.

DC. Do you think Warhol has translated this theory into his paintings?

ELS. I think repetition of imagery plays a much larger part in Warhol's work than he's usually given credit for. His idea is that if you see the same image over and over again, either with no variations or with slight variations, it's finally going to click. And in a sense it's going to give you a different sort of experience than the unitary image. The other thing I feel about Warhol, which again is not a very popular idea with his more committed admirers, is that I find that he has an enormous interest in American violence, and that one of the functions of his art is to anesthetize that violence, to present it as pretty. I only have to quote the title of one picture, made in his usual technique—which consists of making a photograph or finding a photograph, stencilling that photograph on to a canvas and then crudely coloring it with other stencils—work which can be done either by Warhol or by assistants directed by him. Well, one of these pictures is called *Pink Race Riot*. And there is a whole series of pictures devoted to race riots. There's one devoted to car crashes of the goriest kind. The Jackie Kennedy picture inevitably evokes associations with the Kennedy assassination, especially as it's a picture of her taken immediately afterwards. The Marilyn Monroe picture evokes associations with her suicide. Then there's the series of wanted men taken from police photographs. A large proportion of Warhol's work is concerned with

violence, and that proportion which isn't, like the flower series, tends toward the numbly pretty.

DC. Let's go from there to his films, which, if I can turn your phrase around, seem to me pretty numb.

ELS. Well, the films have developed out of this deliberately deadpan style, represented by the man sleeping, toward things like *Trash* and *Flesh,* which were made with the collaboration of Paul Morrissey. And it seems to me that those films which have any dramatic plot are very much, give or take a few differences, the kind of things which you'd expect from charades in an English Edwardian country house. They are filled with "in" jokes. They are tremendously self-regarding. They have one eye on the knowledge, prejudices, ideas of a small group of friends, and the public, I think, thrills to them because it's rather like being let in to Cliveden when all the Astors were acting out a charade. I think that Warhol's appeal to the film audience is very largely based on snobbery, on our being let in to an exclusive, fashionable world, the world of The Factory.

DC. What you are saying, in fact, is that Warhol is one of his own works of art.

ELS. Oh, I think he's his principal work of art.

DC. So, too, is David Hockney, don't you think?

ELS. Hockney's tendency to make himself into a work of art, with that dyed blond hair and those silver lamé jackets he used to affect, has of course been interrupted by conventional talent. He is undoubtedly a gifted draftsman of an absolutely conventional kind. And he has been affected, certainly in his later work, by the

160 *Pop Art*

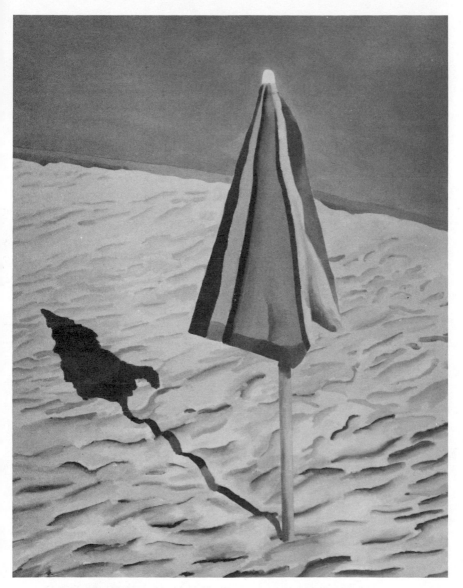

David Hockney, *Beach Umbrella,* 1971, acrylic on canvas,
48 x 36 in. Collection Barbara Thurston, New York, courtesy
André Emmerich Gallery, New York.

preoccupation with modes of representation which I've already spoken about.

DC. How would you place his etchings, or indeed his whole development, in relation to pop art?

ELS. David Hockney strikes me as being really very much an isolated figure, a much less characteristic pop artist than most of the artists who are put in with him. His landscapes, for instance, have a very strong resemblance, which American critics have pointed out, to the work of Edward Hopper, the thirties realist. I think that David's chief pop characteristics are his adoration for things like the civilization of southern California.

DC. Which he is very fond of, and where he spends a lot of his time.

ELS. Indeed yes, and is fascinated by as a source of imagery. He carries a camera all the time when he's there.

DC. Let's talk now about some of Hockney's contemporaries on the Continent. What about Yves Klein, for example? I guess he really ought to be called a Neo-Dadaist.

ELS. Yes, he belonged to the New Realism group which was the intellectual creation of the French critic Pierre Restany, and I think that all his experiments were Dada experiments.

DC. You mean the whole "ceremony" of painting?

ELS. Yes, the turning of it into a ceremony. I think there are artists who were much more directly affected by pop

in France and indeed in Italy. The sort of name which comes to mind is Pistoletto, for instance, in Italy, and Martial Raysse in France. And one of the things one notices there is that they are unable to rid themselves of the fine art bit, in the sense that English and American artists were able to get rid of it.

DC. They still felt Tradition staring over their shoulder?

ELS. Well, if you look at Raysse, for instance, he adapts images but the images are nearly always taken from famous pictures by Old Masters, and not from advertisements. And if you look at that phenomenon in turn, it seems very natural, because you don't have that great pressure of advertising in the environment in France as yet, which you get in England and America. New York and London represent a different sort of civilization to the civilization of Paris or even Milan.

DC. But is Klein an isolated figure in turning painting into a ceremony? For example, he's used a flame thrower, and a woman dragging another woman across a canvas, and once he left a painting out in the rain, and after the rain had fallen on it that was the painting.

ELS. I think that you can relate him to artists such as Arman, who makes these accumulations in plastic of different objects, thousands and thousands of empty paint tubes enclosed in a sheet of plastic, and I think you can also look toward Lucio Fontana, who recently died, who is the author of those canvases which are slashed or shot at. Klein's own absolutely unslashed unitary canvases are related, oddly enough, to early experiments by

Rauschenberg, who at Black Mountain College painted a series of all-white canvases on which the image was the shadow of the person who looked at them or passed by them.

DC. But that wasn't the first time that had been done.

ELS. I think it was the first time that a totally blank canvas, a bland unitary canvas, had been presented as a work of art.

DC. What about Christo's packages?

ELS. That relates to the assemblage movement, and also it's closely related, as I suppose you are suggesting, to Klein and to Arman. But I have never thought him such an important figure in the history of art as the scale of some of his works might prompt one to suppose.

DC. You mean packaging whole buildings and that kind of thing?

ELS. Well, to package a series of cliffs in Australia seems to me a big enterprise but a small idea.

DC. I agree. What about Kenneth Noland or Kienholz?

ELS. Kienholz is usually classified by us classifiers as an example, or indeed the prime example, of what's called "West Coast funk". Of course he is very closely related to Oldenburg in his idea that true realism consists not merely in rendering it in two dimensions, but in three and making an environment. So when you want to make a comment on the subject of a forties brothel called Roxy's, you rebuild the brothel, so to speak, with certain

symbolic additions. My own feeling, especially after the recent Kienholz retrospective exhibition in England at the Institute of Contemporary Arts, is that this process is really rather cumbersome, that a law of diminishing returns sets in, that it's not concise enough for its content.

DC. Do you think Larry Rivers is a pop artist?

ELS. A very difficult question. Rivers has always been an independent. One could say that if Hockney is a pop artist, Rivers is a pop artist. The fine art bit is by no means banished, of course, from Rivers's best paintings. *The Last Civil War Veteran*, or the nude with all the parts of the body carefully indicated in French, are pictures which have a very strong relationship technically to Manet—that is, to mid-nineteenth century painting.

DC. I remember Frank O'Hara once saying that a lot of pop art was a put-on. Is it?

ELS. I think it is a put-on, but in this sense: I said that I thought Abstract Expressionism was the last truly aristocratic style in painting, the style which created a distinction between those who were committed to the avant-garde and those who weren't. I think pop, while attacking this very concept, was also, at some deeper psychological level, very reluctant to give it up, and that the put-on side is an extremely ambiguous phenomenon. At one and the same time it is intended to separate the avant-garde sheep from the bourgeois goats.

DC. It's the canvas winking at the cognoscenti.

ELS. That's exactly it. A very good phrase. At the same

time, it is still meant to leave an avenue of approach open to somebody who doesn't belong to the cognoscenti.

DC. Well, taking that as an avenue of exit into op and kinetic art, which, first of all, do you think is the better word—"op" or "kinetic"?

ELS. I think kinetic embraces op. Op art seems to be kinetic, thanks to the physical mechanism of the eye, while kinetic art proper does actually move, whether at random through the action of natural forces, like the Calder mobile, or by machine power.

DC. Let's talk for a moment, then, about those things that are powered by machines. Do you see machine-powered art as a marriage of convenience between technology and artistry?

ELS. I think if it's a marriage of convenience, it's very much what the French would call a *mariage blanc*: something which will produce no real issue. When you look at the actual technology of powered works, the technology is extremely naive. The artists have not had access to the latest experiments with electronics. They are not trained in electronics. Such things are beyond their capacities. Most machine-powered art, I'm afraid, is a matter very much of second-hand, low-power electric motors.

DC. Are you talking about people like Takis, for example?

ELS. Takis is more imaginative in his use of the natural forces of electricity, the natural sources which are canalized by machines, than any other artist I can think

of. But the theory behind his works—like those magnets which eternally repel each other, like those which are suspended in the air by balanced forces of magnetic attraction and repulsion—is not, in fact, very complicated. If you go to any department store now you will find desk toys for executives which are simplifications of things which Takis did five or six years ago—like the toy which has two magnets which repel each other, which are balanced on rods which continually swing toward each other and then are pushed away again by the repulsion. It's a terribly simple principle. It's of the genre of Victorian drawing-room scientific experiment. I think it's ironic that the most original of all these artists who use machine power is Tinguely, because Tinguely is really a satirist of the machine. What he exploits are its inherent malfunctions, its defects, its crudity and so forth. And it's precisely through emphasizing the aspect which most kinetic artists conceal that he achieves originality.

DC. Emphasizing the very fallibility of the machine.

ELS. The fallibility of the machine is his subject.

DC. Can we move now from works of art that move to works that appear to move when they are on the wall. I'm thinking of someone like Bridget Riley.

ELS. Yes, and also Victor Vasarely. Vasarely springs out of the Bauhaus tradition, though he attended the Hungarian Bauhaus rather than the German one. And you find in Vasarely all those ideas which are quintessentially Bauhaus, like the fact that the work should not be an

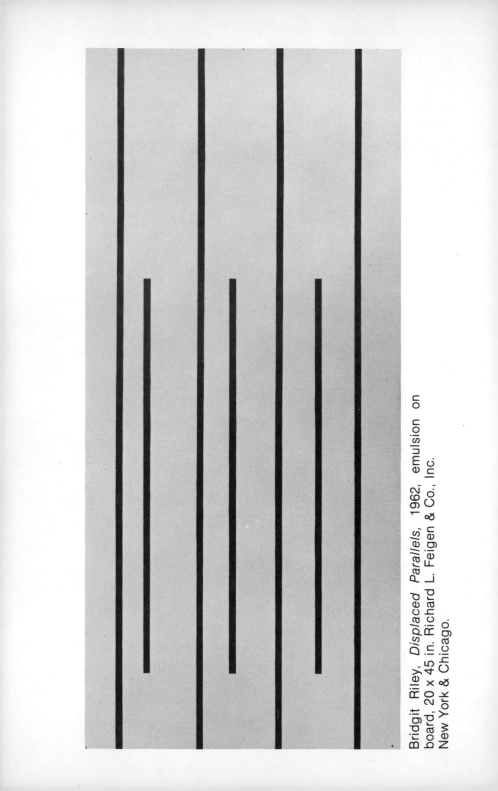

Bridgit Riley, *Displaced Parallels*, 1962, emulsion on board, 20 x 45 in. Richard L. Feigen & Co., Inc. New York & Chicago.

original but an original idea which can be reproduced in different fashions ideally. And the whole realm in which Vasarely experiments—of what pattern does to the eye, of apparent movement through the cunning use of pattern, and so forth—was a realm which the Bauhaus had already sighted even if it hadn't fully explored it. Bridget Riley at first glance appears to be exactly the same sort of artist, but the more one looks at her work in comparison to Vasarely's the more one tends to see that their intentions are in fact totally different.

DC. In what way?

ELS. Well, Vasarely seems to me to have a scientific attitude, to be an experimentalist, while Bridget Riley seems to me to be a poet. Bridget has said to me many times that she means her works to convey an emotion, that they are merely a mechanism for conveying a tone of feeling. Bridget, I think, would like a picture of hers, of closely placed pink and white and green stripes, to give you much the same feeling as the sort of Impressionist landscape, or Neo-Impressionist landscape, in which precisely the same colors appear.

DC. Does she, then, like Baudelaire, invest certain colors with certain emotions?

ELS. No, I think she invests certain optical effects with certain emotions.

DC. But not necessarily the specific colors?

ELS. No, I think that her feeling would be that the color is the servant of the optical effect. You see, I think it's

arguable in her case, even more than in Vasarely's case, that the picture does not exist on the wall, that the picture exists in the retina of each individual spectator, and therefore that every time you look at it you make a new picture. And if I look at it, I make an entirely different picture from the one which you may be looking at at the same time, because our physical make-up is different. And I would contend further that these patterns, in their very optical violence, tend to have a slightly hypnotic effect, and therefore the pictures become what I would call instruments of reverie. They throw you into a light trance state, and during that trance state ideas and feelings float to the surface, become accessible to you, thanks to the effect which the pattern is having on you physiologically.

DC. So in fact that sort of op art should be called "hypnop art".

ELS. Yes, I think that's a very good term. I wish I'd thought of it.

DC. I'd like now to make a slight geographical detour, if I may, because one of the things that's always fascinated me, in thinking of artists like Carlos Cruz-Diez or Soto or Tomasello, is why op art should have caught on in South America when it didn't really catch on in North America.

ELS. Well, I think that South America was one of the last remaining places where Paris retained its old glamour as an art center. Spanish American culture, in so far as it's not Spanish, is French. The result was that just as between the wars talented artists from central Europe tended to make the pilgrimage to Paris, similarly, talented

artists from South America after the war tended to head for Paris rather than the nearer New York, which they felt to be the alien headquarters of the gringos. Once they got there, they fell under what seems to me the only really vigorous and living influence exercised by Vasarely. So Vasarely's disciples are very often South Americans.

DC. How would you account for the fact that New York didn't take to op or kinetic art?

ELS. I think the reason is really very simple, and that is that there was another alternative in America. Pop art was opposed by so-called post-painterly abstraction, supported for the most part by the critics who had supported Abstract Expressionism.

DC. Who do you have in mind?

ELS. The critic I have in mind is Greenberg, and the protegés I have in mind are painters such as Morris Louis and Kenneth Noland and Frank Stella.

DC. Would you consider Noland an op artist?

ELS. It's a fascinating question, because clearly he isn't, and yet clearly at the same time he uses the same patterns which a painter such as Bridget Riley uses for op purposes. That is, both Bridget Riley and Noland in recent years have made use of very large canvases painted in stripes of color, while Riley's colors are calculated to produce strong optical effects on the retina and Noland's are calculated to be absolutely inert.

DC. Here, once again, is something I've never quite

understood. When you look, for example, at somebody like Rothko, and you see these great blobs of paint arranged in a sequence, but with very ragged edges, and then one calls Rothko an Abstract Expressionist and one calls Noland or Riley op artists, is the difference between them simply those ragged edges?

ELS. No, I don't think so. Rothko's pictures, if you look at them, have a certain dynamism. One might even say that there's more likeness, curiously enough, between a Rothko and a Bridget Riley than there is between a Noland and a Bridget Riley. The reason is that those ragged squares or oblongs of color which Rothko uses float in front of the shallow space which I've talked about in our previous conversation. And because the space is a metaphysical space, or inner space, the exact position of the rectangle of color in relationship to what lies behind it is unplaceable. The rectangles of color seem to shield something, and they seem to shield it by hovering back and forth almost. There is a slow optical progression which you also get in the work of a hard-edge artist such as Joseph Albers, who actually began in the Bauhaus and is one of the links between American art and the Bauhaus. Noland, on the other hand, is very careful to emphasize the object quality of the canvas. One of the ways in which he does this is that he doesn't actually paint the canvas, but he stains into it with diluted acrylic color, so that there is a complete unity between paint and ground. They are the same thing, instead of being separate things as they are in traditional painting. And I think that Noland's work, particularly, comes to you with an object quality which one also speaks of in the

case of a painter such as Mondrian, an inert object quality, so that the painting itself is the addition of a new object to a universe of objects.

DC. And it's a quality you don't find in Bridget Riley's works?

ELS. No, I don't find it. I think that Bridget Riley's patterns and her optical effects have the end result of making one think of the canvas not in terms of its objective existence, but in terms of its dynamic effect. Bridget's pictures are effects and Noland's are things. That's the distinction.

DC. To draw back for a second and survey the whole scene, are we in an age of op art, or pop, or both?

ELS. I don't think we're in an age of either. I think that the whole idea of stylistic classification which continued to flourish up to the mid-sixties, and beyond, has suddenly broken down. It's a very interesting phenomenon. I think the only place in which it still survives is sculpture, because sculpture has developed a little more slowly than other aspects of the visual arts.

DC. Why has it fallen behind, if indeed it has?

ELS. I think it hasn't fallen behind, but that rather than exploring pop or op preoccupations—though Oldenburg was three-dimensional, we somehow don't think of him as sculpture—it has explored a world of relationships which is different from either, the world of relationships which consists particularly of the emphasis on the joinings of forms rather than the forms themselves. The two most

important names are David Smith and Anthony Caro—one American, one British—who use ready-made machine forms, but the way in which they assemble them and the actual grammar of the assemblage, the joinings, are the things which count as works of art. And this is yet another preoccupation—neither pop on the one hand nor op on the other—and I think this preoccupation has been sufficiently strong to sustain sculpture in its traditional role, as painting has not been sustained in recent years.

DC. Then we've reached the end of the road as far as categories and movements are concerned?

ELS. And also, I think, as far as formats are concerned. One pop artist we haven't mentioned, whom we might because he is extremely relevant, is the British artist Richard Smith, who has been forced to make canvases in three dimensions stretched over frameworks because simple two-dimensional shapes, even eccentric ones, would no longer serve his purpose.

DC. Which is what?

ELS. Which is, I think, to try to say something about the relationship of color to form, and the relationship of both to forms such as packaging, which one finds in the ordinary universe—the uncooked, un-art universe.

DC. To actually take its place in the universe, rather than hang on the wall of the universe?

ELS. Exactly, yes.

DC. Do you see pop, or indeed op, as an on-going

phenomenon? Or will they be seen from the perspective of the next century as a temporary aberration?

ELS. I think the answer to that question is simply yes and no. In their strict definitions as we now see them, they are closed stylistic phenomena. In the broader sense, pop did lead us toward looking at the urban environment in a new way, and I don't think we will ever be able to rid ourselves of the things which it taught us. And I think that op and kinetic art did suggest avenues of progression which will also be fruitful for the future. The thing which in general I think is dead is that pop and op were the last upsurges of real "stylism", as I call it. I think that we have to find a new mode of criticism which doesn't rely so heavily on slick stylistic categories of the kind which those two were made into by reviewers and journalists. We no longer have a stylistic succession like patriarchs in the Bible.

DC. You don't have Dadaism begetting Surrealism and that sort of thing.

ELS. Exactly that. You see, I think that our tendency as critics has been to look at art as an enclosed activity and now we have got to break out of that particular formulation and see art in relation to society, and we have got to discuss it not in terms of this tyle which is abolished by that style which is abolished by the style that follows, but in terms of how it spreads out, how it has consequences both in the realm of art and outside it. My feeling is that the whole idea of a straight-line history of art has got to change.

VI
The Contemporary Avant–Garde

DC. In a moment I want to discuss where we go from here in the visual arts, but first I want to ask: Where is here? Where are we in the seventies?

ELS. I think we've reached a divide in the seventies. I think that there is a genuinely new situation. And it's easiest to sum up that situation by saying that the old dynamic has come to an end, that post-war art from 1945 to the end of the sixties can be thought of in terms of one style succeeding and devouring the style which preceded it. Now I think we have a situation in which there isn't a dominant style, in which it is becoming very difficult to see what the domain of art actually is. I think we've reached not only a stylistic divide, but a moment of real philosophical hesitation, if one can put it that way.

DC. I tend to think of contemporary art very much as unframed art. All sorts of things are happening in the art world that previously wouldn't have been called art at all.

ELS. I think one of the difficulties is quite simply that the visual arts include everything but the visual, or so it seems to me. They include sequences of actions, they include concepts, they include going for a walk in the country, and so forth. But what it actually looks like is very much less important, quite a lot of the time, than the sequence of actions which led up to it looking like that. If we can take the case of sculpture first, because I think it's much easier to trace this path of development in three-dimensional works, in the middle sixties there existed in England what was called the "new generation" of sculptors, which included people like Philip King and Tim Scott. It included what Americans have rather maliciously called in my presence the "school of British lightweights". And these were sculptors who worked in new materials—mostly plastic, sometimes painted sheet-steel. Most of them had studied at the St. Martin's School of Art in London under Anthony Caro, and they were the next wave of development after Caro. Now, the fascinating thing is that when recently the Tate Gallery was given a large collection of work of this kind by a member of the McAlpine family, the work suddenly looked very old-fashioned, not only to me but I think to many of my colleagues who had to review the show. And the reason why we suddenly found ourselves out of love with it was that we found it curiously undynamic, unadventurous. We found that it cleaved too closely to the idea of fine art for our present taste. It had all sorts of detail modifications, like the use of these materials I've mentioned and like the use of color, usually color which you don't find in nature—those violets and acrylic

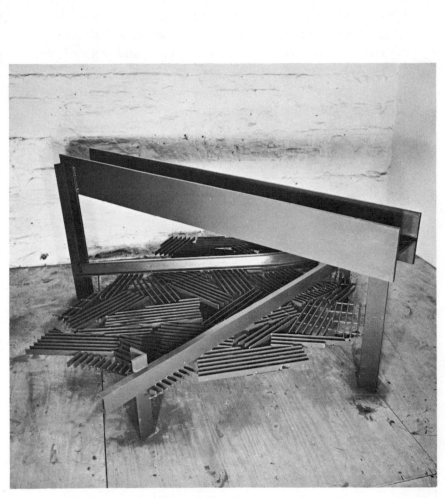

Anthony Caro, *Again,* 1971, steel, 35 x 77½ x 75 in.
André Emmerich Gallery, New York.

pinks and so on. The idea of sculpture sitting on a base had been abolished. These pieces sprawled about the floor, just as Caro's did before them. And yet, all the same, there was something which fell short of our present conception of what art is about. And the show got some very bewildered reviews for this reason. We were searching for the reasons for our own sudden feeling of unhappiness with this kind of work. And I don't think that this was merely that art critics are fashionable creatures and follow the fashion, or are prisoners of the *Zeitgeist*, if one wants to put it in a slightly grander way.

DC. Could we back-track a bit and go back to David Smith, who I suppose was the original river pilot up this tributary of art.

ELS. Not quite the original river pilot, since there's a line of descent which goes from Julio Gonzalez in the thirties. Gonzalez was a trained metal worker, who thought in terms of beaten iron and had a tendency to draw in three dimensions with metal. And Smith took over this tendency and added an American sensibility which had been trained by working in auto plants, for example, and he also, I think, had that very American feeling for the lash-up, for something he's lashed together to see what it will look like, to see whether it will do. And many of Smith's most impressive works are in fact lash-ups of this kind. They are made of scrap metal, of discarded metal parts he found lying about, and they are monuments to discarded technology in that sense.

DC. And very large monuments at that.

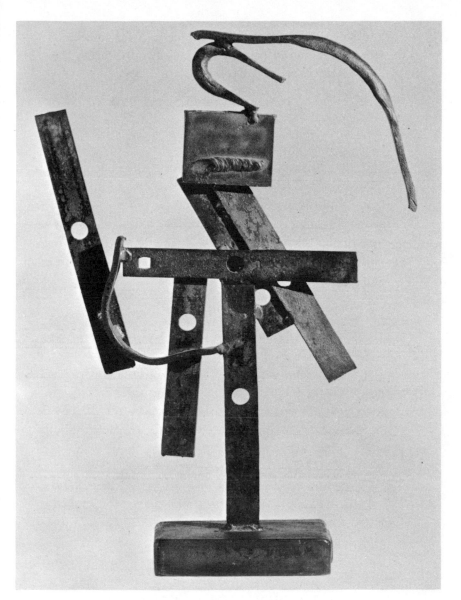

David Smith, *The Bar-Head,* 1956, steel,
25 in. high. Marlborough Gallery, New York.

ELS. Yes, there's that whole series he made at Spoleto, when they invited him to come and work down there, from material he found lying about.

DC. He had a prodigious output, didn't he?

ELS. Well, one of the reasons why it was so prodigious was that he in fact collaged together already formed parts. And that tendency was in turn inherited by Caro, though Caro was much less inclined to use scrap and much more inclined to use parts from an industrial catalogue—that is, I-beams cut to length, pieces of metal mesh cut to a particular size, and so forth. And then the younger sculptors discovered the convenience of fiberglass in particular.

DC. You're thinking of Philip King?

ELS. I am thinking of Philip King. And the custom then became to make a plywood mock-up and then send it off and have it industrially produced. But of course Gonzalez was very much a craft artist. King and his colleagues are very much not craft artists, I think. And where one got an unexpected kind of relationship was that the sculptors in plastics and so forth did come very close to the world of commercial exhibition design. When I first saw them in 1965, and every time I've seen them since, it seemed to me that a better description of sculpture of this kind would be that they are exhibition objects, using that term in really rather a special sense, because what context have they other than that of an exhibition, other than that of the museum as we now know it as a medium of popular entertainment and popular instruc-

tion? They are not made to be put outside. They don't stand up to the weather, especially when they're in things like fiberglass. They occupy an enormous amount of space, too much space for any museum to keep them on permanent display. The Tate has had to pack up the bulk of the McAlpine Collection after its initial exhibition. These are, in fact, pieces which are brought out and re-assembled for special occasions. And that leads one to some rather discouraging reflections about their social function. They don't do any of the things which sculpture did before. They don't serve to organize a landscape, for example, as a fountain figure would do in a Renaissance garden. They don't serve to commemorate anything, like the humblest village war memorial. They are not a *bibelot*, something which you could own for private pleasure. Collectors have rapidly discovered that one of these is about as much as anyone, even a member of the upper middle class, can hope to house. In fact they are superfluous objects, and I think it was that feeling of superfluity which led to disillusionment, certainly with me when I saw them again *en masse*. I thought this was really too much fuss about too little in the way of content. Well, after that kind of sculpture—or rather parallel with it, but in America—there was another phenomenon, and that phenomenon was called "minimal art". Minimal art started off by being large cubes and boxes and so forth. A characteristic sculptor of that phase was Tony Smith, who started as an architect and who actually used to order his sculptures by telephone from the metal workers sometimes. That is, he would simply draw up a chart of the dimensions, read off the dimensions to his firm

of makers, and back it would come. But there were also other aspects to minimal art. Some artists, such as Sol LeWitt, were particularly interested in grids and sequences, and in this they resembled the stripe painters. In other words, if you put down a grid in a gallery—a set of boxes, a set of flat plaques, all of identical size—these can be seen as a specimen from a much larger assemblage of the same kind: where the piece stops is arbitrary. Then after that there was a phase in which form itself was abandoned in minimal art, almost a back-tracking to *art informel*, and you got pieces like the felt pieces of Robert Morris which were deliberately amorphous, heaped-up. And then, finally, you got the branching forth into what has been called "land art" and "earthworks", the alteration of the landscape, the digging of trenches in the desert, the building of circular jetties in remote lakes in America, and so forth. And here the whole question of evidence becomes very important, since most people couldn't go and see the work. And sometimes, since the work itself was purely ephemeral, since it was covered up by the next dust storm or whatever, then the photograph indicating that it had actually been done became a very important part of the process. At the same time, you got a feed-in from the happening. The happening was originally, as you know, a pop art phenomenon. It was a kind of avant-garde theatre invented by artists. It was a series of actions designed to produce the same kind of sensations as a work of avant-garde art. You might think in terms of Rauschenberg's combine paintings. A happening was a combine with

a temporal sequence in which you actually used people as well as things. What happened, in my opinion, with the happening was this. First of all, the happening fed not back into the visual arts, but into the theatre. I think it administered a tremendous jolt to styles of theatrical production, and I do feel that the whole off-Broadway and off-off-Broadway scene was very largely powered by ideas which had first of all been tried out by artists.

DC. The same could be said even of some of Peter Brook's productions.

ELS. Then later on it went into the formal theatre. And it's not only Peter Brook who was influenced, but people like Ingmar Bergman even. That was one side. Then I think the happening inevitably, since ours is a technological society, moved over into the field of the underground movie—many of which were, I think, initially simply records of happenings—and at last into the field of video.

DC. Can you describe a typical happening, if that's not a contradiction in terms? I suppose even back in the early fifties John Cage and Merce Cunningham were putting on what one could almost call happenings at Black Mountain.

ELS. Cage and Cunningham were among the originators of the happening, and their inspiration in turn came directly from Dada and Futurist cabaret performances, particularly in Moscow and in Zurich, during the First World War—from the accounts they read of them, from their desire to revive that kind of thing. I don't think

there is any such thing as a typical happening. A happening may be one man performing a minimal sequence of actions, or it may involve great mobs of people.

DC. How would you summarize the aesthetic theory behind happenings?

ELS. Well, I think the happening is totally anti-dramatic in form. The pure happening is distinguished by its anti-dramatic element: it leads up to no climax, it has no logical plot, it is a series of poetic gestures. Its nearest relation in the true theatre is the dance, and that of course was one of the reasons why Cunningham was able to feed his ideas into that sort of context, and why he has been able to collaborate so very closely with Rauschenberg. But it may involve anything. I can remember Henry Geldzahler, now of course a prominent museum official, telling me some years ago that he felt perfectly splendid that morning because he had spent the previous evening floating about in a rubber boat in a swimming pool as part of somebody's happening. This was somehow a purgative experience.

DC. I'm sure it was. But is the happening still happening?

ELS. I think there's been a revival of happenings, especially in England, though this second phase is slightly different in tone. You do find among young British artists—I'm thinking of artists under the age of 35—quite a high proportion who think of their work in terms of actions, actions of different kinds. And you do find quite a lot of them who only work in collaboration. There have grown up a number of performance troupes where

it's difficult to say whether they should be thought of as fine artists or as members of the fringe theatre. And the sort of thing which happens is that we now have a kind of laboratory for this kind of activity in London, in the form of the Serpentine Gallery, which is a small pavilion which sits on the border of Kensington Gardens and Hyde Park—that is, absolutely in the residential center—and on bank holidays the Serpentine Gallery has been staging a number of events of this sort. The events have fallen into two different categories. On the one hand there have been people wandering around performing. That is, they have made themselves into temporary works of art, they have suggested by their actions a network of art relationships, if one can put it that way. I'm thinking, for example, of a group called "The Welfare State", who dressed themselves as old-fashioned theatrical performers, and they had a large lawn on one side of the gallery, and they performed different sorts of actions. For instance, there was one man who appeared as a seedy conjurer and who harangued the crowd, but who actually never got around to performing any kind of conjuring trick. Your expectations were always disappointed.

DC. And that was part of the intention.

ELS. That was part of the intention. And then there was another group of two men who set up a Punch and Judy booth in a different part of the space. And there again no performance ever happened. One of them came out with a glove puppet and said that a performance wasn't going to happen. Then again there was a man who spent all afternoon dressed as a clown, and he'd made a great

pile of park deck chairs, and then as soon as he had finished he knocked them down again and started in a different place. And there was yet a fourth action where somebody had a can of black paint and an umbrella, and he very, very carefully painted the umbrella black.

DC. What was it originally?

ELS. Black.

DC. I thought so.

ELS. Well, these actions pulled the crowd, which was a very considerable one, back and forth within the space. What they were playing on partly was that anxiety over missing something which affects crowds. And oddly enough, people didn't seem in the end to feel frustrated or cheated by these deliberately open-ended acts. They felt somehow that they had undergone a poetic experience. On the other side of the gallery we had something which exemplifies a different approach. We had a series of inflatables, large structures and large objects, mostly made of plastic and simply pumped up with air, mattresses you could jump on, cushions and so forth. And these were interesting from two points of view. First of all, they were examples of technological co-operation. They obviously couldn't have been made without a great deal of help and sponsorship from firms who specialize in this sort of material. And secondly they exemplified that philosophy of modern art which says that you cannot merely be in a spectatorial relationship, but that you must be able to involve yourself physically. And participatory art, I think, has become enormously important.

It has also attracted many of the founders of minimal art, notably Robert Morris, who last year made an exhibit for the Tate which was, I thought, nothing more nor less than an old-fashioned army assault course, and which was so dangerous to the public that it had to be closed after a week. Well, the inflatables are much the same kind of thing, except that you are very much less likely to break your neck by participating. And I think behind the philosophy of involvement and the philosophy of co-operation with industry there was another, more general thought, which was that since art has lost all its metaphysical qualities, what it is now is fun. I've spoken of art as having been to the Egyptians part of the cult of death, and having been to the courtiers of Louis XIV part of the cult of power. Well, I think that now, in a secular democracy, one of the things which one might perhaps claim is that the only thing which art can seriously be is frivolous, a plaything.

DC. Is that necessarily true? When you began talking about this group called "The Welfare State", I started wondering if there has been any attempt to relate happenings of the sort you were describing to their social context—indeed, to the welfare state we live in?

ELS. Well, "The Welfare State" itself does do actions which are very much less hermetic than the one which I've just described. In fact they also perform satirical plays, sometimes at political meetings, and they act as a perfectly straightforward street theatre group.

DC. What about people like Allan Kaprow or Jim Dine?

To your knowledge, have they ever related their happenings to an overtly social context?

ELS. I don't think the happening in that original phase, in the hands of its inventors, two of whom you've just named, did have a very close social involvement. I think that, since it has passed into the hands of the avant-garde theatre, and then back into the hands of artists again, one of the things which it brought over from the process, from the theatre, was the feeling of political involvement. You could argue, indeed I did argue and do argue, that Peter Brook's celebrated political show *US* was nothing more nor less than a vast happening, but the thing which distinguished it from the original happenings, quite apart from its scale and its theatrical expertise, was the strong element of political commitment.

DC. I'd like to go back now to something you mentioned briefly in passing a moment ago, and that's the influence of technology on contemporary art, and vice versa.

ELS. There's clearly an enormous problem here. The problem is that modern technology is very complex and very expensive. It's outside the resources of any private individual, however well informed about the project, and indeed however well provided with money. In order to plug into really experimental technology the artist has got to have industrial help, and has got to be able to co-operate with industry.

DC. This sort of thing has been going on in Los Angeles, hasn't it?

ELS. It's been going on in Los Angeles, and it's been going on to a lesser extent in England as well. In Los Angeles the group is called "Exprcriments in Art and Technology". And, as I understand it, they are very happy to accept help in many forms from industry—that is, to accept materials, to accept occasional scholarships, to accept sponsorship in whatever form it comes. In England there has been a tendency to be more puritanical and say that the artist must have a working relationship with whatever industry interests him. He must be taken into the bosom of the company, so to speak, he must be free to work within the company structure and so forth. And the tendency here is also to claim that mere hand-outs are a way of keeping the artist away from the true sources of technological experiment. My own feeling is that one can't be too fussy about this kind of thing. But I have another feeling which is less complimentary to the artists concerned, which is that their experiments with technology are really a little fanciful, that they are cake decoration, that technological art either consists of gimmicks or it consists of the use of relatively simple, and usually outdated, technological processes or relatively simple and outdated machines, simply to power the work.

DC. You called it "technological art", so in fact one is categorizing an art form in terms of the process rather than the product.

ELS. Yes, but I think there's also been a tendency to try to present, especially in America, spectacular

technological shows which take off from the big kinetic art funfairs which have appeared in Paris and London in recent years, which are I think just as much a visit to the funfair as any visit to Battersea Park or Coney Island.

DC. But-would you agree that one of the characteristics of contemporary art—this emphasis on the process rather than the product—is true also of happenings?

ELS. That's quite true, and we have the name "conceptual art" to try to deal with it. I am increasingly skeptical about the validity of the references made by conceptual artists.

DC. For example?

ELS. Well, I'd like to repeat a rather labored epigram which I once fathered, and it is to the effect that minimal art is a great deal of argument about very little and conceptual art is a great deal of argument about nothing at all. You can look at it this way, you see. In both cases the end product—your metal box, or your heap of felt, or your series of photographs of some action which has been carried out, or your written account of an "art walk" taken by the artist—is justified within the art world by elaborate philosophical explanations, usually carefully decorated with the terminology of whatever philosophical school happens to be most in fashion. At the moment I suppose it's structuralism. But that is all very well for those who are committed, who are part of the art world, who are part of the art community. I don't think it is at all very well for the ordinary member of the public. Now you

may argue that art has always been something that you had to work at, that it has never yielded its truth to people who took it superficially, and therefore the ordinary man, if there is such a creature, who wanders into a conceptual art exhibition and gets nothing out of it because he has no background, is no worse off than the ordinary peasant who wanders into Chartres Cathedral and doesn't get very much out of the stained glass. I myself think that this is a fallacious argument—first of all because I think it isn't quite true. I think that the stained glass may have given more to people who were clerks and could read, and in that sense understood the Bible, but it gave something even to people who didn't have those advantages. My suspicion is that a great many works of extreme avant-garde art in fact give nothing at all. The other thing which bothers me very considerably, because it's a paradox which I find intolerable, intolerable really from the point of view of principle, is that it seems to me that we have an avant-garde which, though it mouths a great deal about revolution and Che Guevara and Fidel Castro and Mao and museums for the people and all that kind of thing, is in fact devotedly aristocratic, exclusive, clannish, out of contact with the great mass of the community. Now I'm aware that when I say this I begin to sound like a Marxist critic. It sounds as if the next step is for me to say, well, we must have figurative art back again, we must have socialist realism and all the rest of it. Well, that is not really quite what I mean. I'm not so impertinent as to propose solutions, but I do think that I am entitled to put forward certain criticisms as somebody in the art world. And those criti-

cisms center about this point. I would like to point to some of the ways in which avant-garde art is specifically aristocratic. First of all, I think that one can say that while there is no longer an aristocracy of money connected with art, there is an aristocracy of youth. Let me take the case of the Robert Morris exhibition at the Tate, which was closed. This was supposed to be an exhibit which offered you the chance of exploring your own physical responses. I would have said that you had to be both in good physical condition and under the age of 35 to venture upon most of the physical experiments which it encouraged you to perform. For example, you had to shin your way up an artificial reconstruction of the kind of rock chimney which rock climbers use. You had to walk on a rolling log. You had to walk along catwalks some way above the ground. Well, I have no doubt that the younger visitors to the Tate, and we know from statistical surveys that a very high proportion of them are in the age group I have designated, did enjoy this enormously. In fact they enjoyed it so much that they scared the Tate authorities almost out of their minds. But I am equally sure that this particular exhibit can have conveyed very little, and can have done very little, for older and more sedate members of the public. Now, has any work of art the right so firmly to exclude one segment of the public in a democracy? Look at it another way. You see, if you hang a Titian in the National Gallery of Art in Washington, or in the National Gallery in London, that Titian is at least physically accessible to every member of the public from the age of five to 95. According to their background, their sensibility and so forth, they

will get varying things out of it, and they will get very varying quantities of pleasure out of it, depending for one thing on whether they like sixteenth-century Venetian painting or not. But potentially it is a much more democratic thing, I would argue, than the Robert Morris exhibition I've just described. I'm not even talking about the quality of the experience. I'm talking about whether you can get an experience at all. Well, that is one way in which extreme avant-garde art of this kind is actually exclusive rather than inclusive, as it pretends to be—and is more exlusive, for instance, than things which do address themselves to the young very largely, such as rock music, because it is not impossible for a great-great-grandmother of 90, of a certain cast of mind, to enjoy the roughest, toughest, hardest rock you ever heard. It's probable that she won't, but it's not impossible. Whereas poor old granny in her wheelchair is no good in Bob Morris's constructions. It's just not on. Another way in which this art bothers me is that you get this enormous top-hamper of philosophizing, this super-structure of ideas. And this superstructure of ideas is really, as far as the art goes, completely self-referring. It keeps on turning you back into the art world. It doesn't turn you out toward other kinds of experience.

DC. This has always been one of the things that has bothered me most about the most extreme avant-garde art that I have myself seen in recent years: that it doesn't come to you naked, as it were, but clothed in this fig leaf of apologia.

ELS. And you have to have read the apologia to get it.

And in any case it always turns out to be statements about art. You'll remember that I said of pop art that there was the paradox that it appeared to be popular, to use popular imagery, and yet so often its inner meanings were connected with the grammar of representation. Well, this tendency has been taken very, very much further. And it went far enough in many works of pop art. I remember a work by Joe Tilson, a British pop artist, which consisted of many repetitions of the word "Yes". Well, it transpired, when you made enquiries, that in fact this was an allusion to the famous monologue of Molly Bloom in Joyce's *Ulysses*, where she keeps on saying "yes".

DC. At the very end.

ELS. At the very end. Now I have no notion whether that work of art could be relied upon to convey anything to somebody who hadn't been told or, even less likely, hadn't guessed that this particular kind of slant was intended. You may say that the mere repetition of the affirmative gave something. I don't know. But I do think that there is something very hermetic about all these experiments, something very exclusive, very inaccessible.

DC. So that, broadly speaking, you're saying that not only the ordinary man has been excluded from what we think of as the conventional experience of art, but the extraordinary man also.

ELS. He's in the process of being excluded. And there is another difficulty, which I think allows me to use the word "aristocratic" again, which is that there is to

my mind a displeasing and, I would even say, immoral dichotomy between the ideas about art put forward by many avant-garde artists and the ideas about life which they also put forward. And this dichotomy seems to me exactly the sort of thing which one can detect in the French society of the eighteenth century.

DC. Can you give me an example?

ELS. Yes, I think I can, certainly in broad terms. These artists are always the ones who are at the moment most politically active. And, as you know, there has been a great deal of political activism in the art world during the late sixties and early seventies. In fact, as the economic situation throughout the world has deteriorated, one has had a revival of the political activism of the thirties.

DC. And you're saying that this political commitment isn't in any way plugged into their artistic preoccupations?

ELS. It's *not* in any way plugged into their artistic preoccupations, and it seems that they find it very difficult to make works of art which in any way express what they tell us are extremely important parts of their own lives.

DC. And you feel they should?

ELS. I think naturally they should. What is the good of being an artist if you can't express the ideas which you say are, practically, most important to you?

DC. But they would probably turn around and say that

what you are demanding is a propagandistic content in their work.

ELS. Well, if their activities are highly propagandistic, full of agitations, sit-ins and so forth, it does seem a little illogical that their work should remain so firmly closed in upon itself.

DC. In other words, they should put their art where their mouth is.

ELS. That's a good way of putting it. I do feel, too, that whenever there has been a confrontation between the public and this kind of art, two things tend to happen. At the worst, there is baffled incomprehension. The artist who cries loudly about society is the one who is least able to make himself understood, as an artist, to any kind of mass audience. That too is a situation which I think one found in the France of the eighteenth century. What I am saying is that modern artists are very like the less attractive of the *philosophes* in the reign of Louis XVI. And I am also trying to say that there is a very strong element of the less attractive elements of Rousseauism in many of their pronouncements.

DC. So what's the answer? How can art be sprung from this trap of elitism?

ELS. It's very difficult to say. You see, we're really in a trap which is much older than that, which is the Romantic movement. And I think that modernism is undoubtedly simply an extension of the Romantic movement. I am in no doubt about that. And what this did, eventually, was to get rid of the idea that the work of art should

be of any practical use. We now take it absolutely for granted that the work of fine art for us is that which is of no practical use. But it wasn't always so. In fact, works of art very often had practical connotations: maybe as simple as serving as a fountain, maybe as metaphysical as serving as a statement about kingly power. But they had *some* kind of function in that way. Now the work of art has become almost *par excellence* the useless object. And at the same time it has become more and more unwieldy, impractical, fragile, ephemeral, hermetic. Now, I don't think that one can logically preach social consciousness as an artist without practicing social communicativeness. And what I would like to see in the art community is a good deal more hard thought than is going on at present about the artist's relationship to the society which supports him. I think that this hard thought is particularly urgent because it's becoming clearer and clearer—certainly in this country, and I believe it will happen also in America—that the major part of the artist's support is going to come from public funds.

DC. Are you saying, then, that the solution to this is a kind of Neo-neo-classicism with a social conscience, and perhaps a functional use?

ELS. I don't think I'm quite saying that. I do think, oddly enough, and here I suppose I join with the Constructivists, that the future of the individual work of art, the easel picture so to speak, is rather doubtful. It seems to me that economics demand the serious production of works of art. If you look at young collectors, they repres-

ent a considerable financial force taken as a group, but as individuals they are rather feeble financial forces. And this is one of the reasons why modern prints are such very good business in the United States and Britain. David Hockney can easily make a considerable sum of money from a large edition of etchings, where he would be much harder put to make as much from a painting, especially if he were confined to the British market.

DC. It's also a much more democratic art form, if only on statistical grounds.

ELS. Yes, and the other thing which I'm very struck by is that if you take the realm of industrial design—and we're accustomed to saying, "Oh well, of course the objects for use have been getting uglier", while I'm by no means convinced that this is true—when I go and look at really good modern design, I am struck by its sculptural power. And I think that in many cases, if it's possible to think of a modern environment where the things you use have so much sculptural and pictorial quality that they virtually elbow out the need for works of art, they do give that sort of satisfaction in the environment. What I'm trying to say, therefore, is that we are going back to the situation—which has existed in other societies, such as that of ancient Athens—where the major work of art is *par excellence* a public statement made for everybody, supported by the state, and which fits into our feelings therefore about public life, about the quality of life in the society as a whole. Which is exactly what the Parthenon did. That was a statement about the quality of life in that society viewed as a whole.

DC. Do you think that the situation we've reached now, where it's one in-group creating art for another in-group, is just about over?

ELS. I don't know that it's over, but I do think that it's unhealthy. I wonder how much longer, you see, one can go on demanding larger and larger sums of public money for increasingly rarefied experiments. Why should the state pay Artist X so much to hire a helicopter and two mechanical diggers and a crew of photographers to go out and do a bit of "land art" in the desert where nobody will ever see it, where it is entirely a philosophical gesture? Are our societies so very rich that they can afford extravagances on that particular scale? Does art have to be that sort of folly, that expression of superabundance?

DC. In talking of state patronage we're talking primarily of Britain. What would you say is the situation in America?

ELS. I think the situation in America is that museums are much more closely integrated into the community than ours are. Just as the chapel or the church used to be the community focus, everywhere I've gone in the United States I notice that the museum takes over this function as society gets more secular, and in your case museums are fortunate in that there is a much greater sense of connectiveness with art activity. On the other hand, the actual funding for art in America does come very much less from the state in proportion to the funding in Britain. It's supplied more by private individuals and by corporations. In a much more socialized society, such

as England, the money has got to come either directly from the central government, or it has got to come from local government. The proportion of support from private individuals is falling year by year, and there has been much less success than people hoped in getting industrial support.

DC. Do you think this is because of the hermetic quality of much contemporary art?

ELS. I think it's in part because of that. But I think the other thing which one has got to say is this, and it's something which artists are always reluctant to face. You take a work of art—any work of art, from the very simplest and most obvious, most accepted, easiest to understand, to the most hermetic and complicated—and you launch it like a paper boat on a stream. As soon as it's made—or indeed, in conceptual art, as soon as you embark on the process of making—it to some extent departs from your own artistic control. And you have an element of even unwanted collaboration or co-operation from the public. I think the curious thing is, and I see this particularly at the Serpentine Gallery in London, that here we have—since it's in a public park and it's a free gallery—an absolutely direct confrontation with the public, many of whom never go to art galleries at all as far as we can make out. They stumble upon the gallery in the course of their walks in the park, and they get curious and go in. And they are able to respond to some things, perhaps not always in the way the artists intended, but they are able to get some enjoyment out of them. But this enjoyment is never predictable. One way in which

the public does respond strikes me as being very curious, and to contain a lesson—not altogether a palatable lesson. We notice at the gallery that the public responds indeed to the "fun" concept. Our inflatables have been an enormous public success, and when we did them over public holiday weekends people kept on coming back during the week with their kids and asking why they weren't still there. But it was also quite clear that if those inflatables, or anything else put on at those holiday weekends, had deep philosophical implications the public was absolutely determined to ignore them. They weren't interested at all in that kind of thing. In fact, the deeply philosophical, poker-faced, serious conceptual artist doesn't meet with rage and incomprehension any more from the public in the kind of democracy we have in Britain. He meets with a kind of cheerful trivialization. The public accepts him, pets him, but it is determined to take him at a valuation quite other than the one which he puts upon himself. The artist, because he walks on stilts, is regarded as a public jester. And I think that artists are going to have to be very careful that they aren't permanently allotted this particular role, that of simply the clown.

DC. Do you see any sign of their awareness of this?

ELS. My experience of young avant-garde artists is that they are very lacking in a sense of humor, especially as far as their own activities are concerned. Since I am so much concerned with the promotion of avant-garde art, I have to make strenuous attempts to suppress my own sense of the comic very often. But if I didn't have

those responsibilities, I am sure I should exercise it more often. And I don't think that I would really be a Philistine for doing so.

(Recordings of these conversations are available on Audio-Text ® Cassettes from The Center for Cassette Studies, 8110 Webb Avenue, North Hollywood, California 91605.)

Index